Calligraphy ESSENTIALS

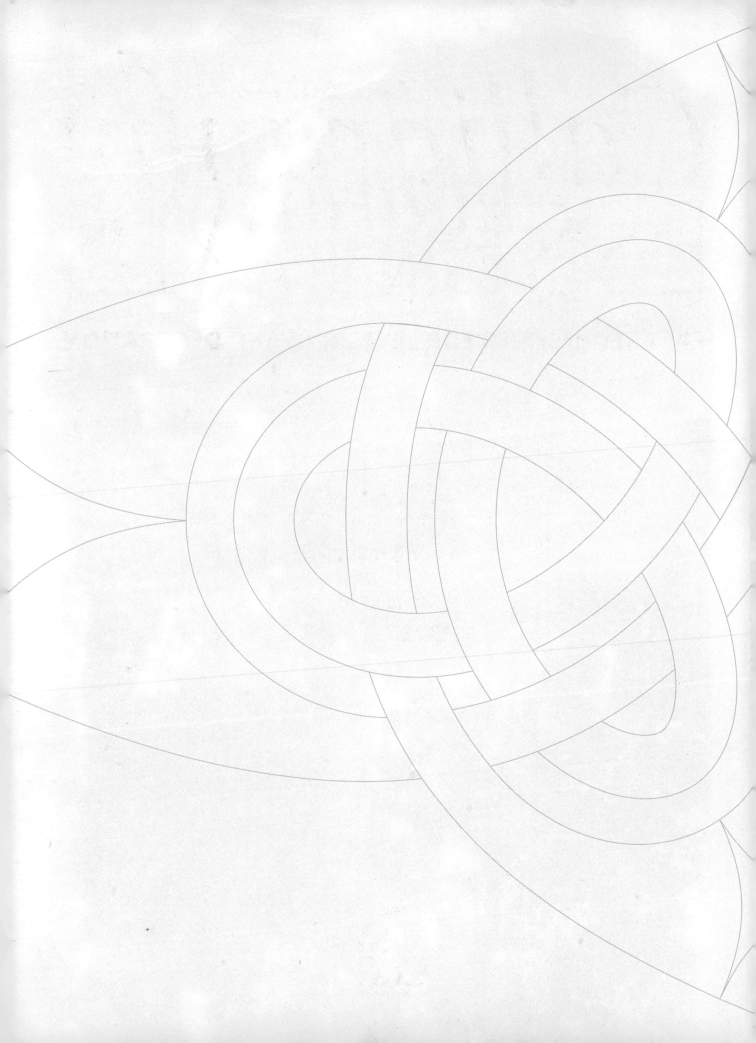

CARI BUZIAK

Calligraphy ESSENTIALS

EASY TECHNIQUES FOR LETTERING AND DECORATION

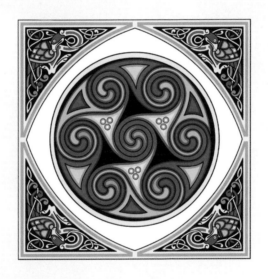

D&C
David and Charles

Table of Contents

Introduction

Calligraphy is a fun craft to learn, as well as a useful one. Far from being an obsolete skill, more and more people today are picking up the pen and creating their own greeting cards, wedding invitations, fine art projects, and even creating their own computer fonts!

In the old days, calligraphy tools were unique and specifically crafted to their task. Today, a calligrapher has a wide variety of tools from which to choose, from traditional to completely modern, even digital! Calligraphers can now experiment with their artistic expression, freely mixing creative ideas and elements together to explore new artforms with their projects. In this book we'll examine the basic techniques of calligraphy, covering calligraphy hands suitable for a wide variety of projects and easy for a beginner or intermediate calligrapher to practice and learn. We'll also cover easy decorative techniques such as watercolor painting, Celtic knotwork, gold leafing and illustration ideas to create a "toolkit" of creative techniques. You'll learn how to make your own wedding stationery, create a painted greeting card or a birth announcement, design a logo for your own business, and so much more! We'll cover all the steps from basic layout to design choices to the final completed piece in easy step-by-step examples.

Calligraphy is a way of expressing yourself and learning something new in an art field that has lots of potential for new discoveries—finding new ways to embellish your lettering, learning a new alphabet, or creating memorable keepsakes with a handmade touch for yourself, family and friends.

Glossary of Terms

Ascenders & Descenders

A letter has three main parts: the x-height, the ascender, and the descender. The main body of the letter fills the x-height (for example, the lowercase "o"); the ascender rises up above the x-height (the stem of the "d"); and the descender falls below the x-height (the stem on the lowercase "p").

Font

A typeface (alphabet) used on a computer (as opposed to letters used on a printing press, or hand written).

Font Family

A font family includes a number of related font faces, such as a bold version, condensed, italic, light, etc.

Cursive

A more fluid or script style of writing, developed as a faster way to write by monks. Cursive usually has a looser and less formal look. It's useful for projects that need letters that flow and move in the design without looking too formal or stiff.

Majuscule

Capital or uppercase letters in an alphabet. Also great for creating a splash at the beginning of a text with a larger or more detailed letter. Often used for monograms, or a detailed piece in stand-alone uses where there may not be any other text or designs in a project. A highly decorated Majuscule used at the beginning of a word or sentence is called a "Display Capital."

Minuscule

Lowercase letters in an alphabet. Some minuscule letters lend an informal look to a piece of text, and can be used in projects where a lighter or more inviting feel is desired.

Uncial

A style of writing characterized by full, rounded letters. Capitals from our modern Latin alphabet are derived from Uncial style letterforms.

Serif

A small stroke at the beginning or end of a main stroke. A serif can be made in many ways and often gives a particular alphabet its characteristic look.

Glyph

Any graphic within a font. This can be a letter, number, or a symbol such as a dollar sign or punctuation.

Encoding

Each glyph is encoded with instructions so that the computer knows to type an "A" when you press the "A" key on your keyboard. At one time Macs and PCs used different encoding instructions or standards; however the new Unicode Standard is a universal standard that both Macs and PCs will recognize and understand and what we'll be using in our discussions here.

Metrics

Spacing rules that you want your font letters to follow so that they're spaced correctly when you type words and paragraphs.

Color Hue/Tint/Shade

Hue is pure color. Tint is color plus white. Shade is color plus black.

Complementary Colors

Colors opposite each other on the color wheel. Complementaries can create strong and bold color pairings.

Triad Colors

Three colors, each one-third away from each other on the color wheel. Triads can also create a very bold color combination.

Split Complementary Colors

Instead of using the direct complementary color, you use the two colors to either side of the complementary. This combination is more subtle, and good for more reserved pieces.

Gilding

The application of tissue-thin sheets of metal (gold, silver, copper) to a sticky surface.

Calligraphy Tools and Supplies

Calligraphy is not an expensive craft to learn. With some basic pen supplies and papers you can immediately begin learning how to create beautiful letters.

Sketching Tools

To sketch your designs and plan your layout you'll need a pencil or two and a good eraser. These actually come in a much wider variety than what we've all used in grade school! Having a few choices in pencil leads and a good eraser to use can mean the difference between fighting your materials while you work, and getting into the groove of your project, so it's more than worth the small cost to purchase these.

TYPES OF PENCILS

You can buy your pencils as normal pencils that are sharpened with a pencil sharpener, a holder that can accept leads of any hardness, or a mechanical pencil. I prefer to work with mechanical pencils because they don't have to be sharpened. I buy a few of those brightly colored plastic mechanical pencils in different colors and color-code what pencil holds which hardness of lead.

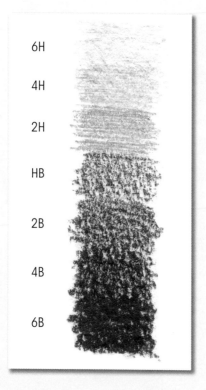

6H

4H

2H

HB

2B

4B

6B

PENCIL HARDNESS

Pencils come in different hardnesses of lead, from 6B (which draws very soft, smudgy black lines) to 6H (which draws hard, thin, silvery lines). For calligraphy or for sketches that will be colored over, buying a normal HB pencil and a 2B or 2H will suffice.

VINYL ERASERS

Vinyl erasers are a standard for sketching. They come in a variety of sizes, however I find the easiest thing to do is buy a big block and then use a utility knife to cut it down to whatever size I need. I also trim off the corners of the rectangular eraser into small wedges that I use to erase in tiny places—very handy for detail work when drawing embellishments and designs!

KNEADABLE ERASERS

Although a kneadable eraser is sold in a rectangular form, you can knead it into any shape you want! Rather than rubbing it across your work like a normal eraser, press it against your pencil lines, then lift it off.

Since it only removes a bit of the drawn lines at a time you have a lot of control with how much you lighten or remove. It's also great for sensitive papers because it gently removes the pencil lines on delicate papers that could be abraded or ruined by rubbing.

Learn more about calligraphy at http://CariBuziak.artistsnetwork.com

Calligraphy Pens

Calligraphy can be written with any wide chisel-shaped tool, whether it's a pen, a felt, or the reed from a musical instrument! The key is the chisel-shaped edge used to make the letters. By holding the chisel edge at a consistent angle and moving it around your paper, it will create thin and thick lines automatically for you.

The three main types of pens used in calligraphy are the traditional dip pen, a cartridge style pen, and a felt tip pen. Try each to see what you're most comfortable with across a variety of uses. For practicing and planning pieces it's handy to whip out some text with a felt pen, while expressive works and works needing a wide range of nib widths would work better with a dip style pen. A cartridge style pen is handy for long pieces of text that need consistent letters because you just load it up and start writing!

Each is useful in its own way, but if you can only buy one style, I would recommend buying the dip pen holder and some nibs and ink because it's the most flexible to work with overall. Once you become more familiar with calligraphy, experiment with any chisel shaped objects you can find!

FELT TIP PENS

The felt tip pen is like an ordinary felt pen, except that the tip has a wide chisel edge, not a point. A great tool for beginners, these pens are inexpensive, do not require reloading or filling with ink, and come in a variety of colors and widths. However, because the tip is made from felt, it can wear down and soften over time and you'll lose your nice crisp edge for lettering. Also, the ink isn't archival so it's not suitable for important projects

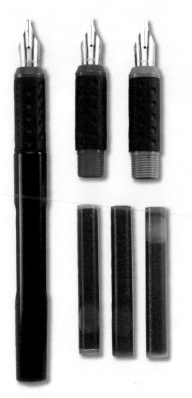

CARTRIDGE STYLE PENS

The cartridge style pen works like a fountain pen, except that it has a chisel nib for making calligraphic letters. To use these, you insert ink cartridges into the pen and add your preferred nib. Inks come in a variety of colors, and nibs in a variety of widths.

These pens are nice for students because you get an automatic flow of ink as you write, and you can write for a very long time without having to change ink cartridges. However, it can be tedious to change colors or nib widths because the ink chamber and nib must be thoroughly cleaned and flushed free of any ink that could dry inside.

Calligraphy Pens

DIP STYLE PENS

A dip style pen, the kind you see in old movies that is usually associated with calligraphy, has a handle with a small opening at one end where the calligraphy pen nib is inserted. It's very simple to change nib widths and colors because the nib is accessible and easy to clean. However it does take a bit of practice to figure out how much ink to load into the nib, and to gauge when you're going to run out and need to redip.

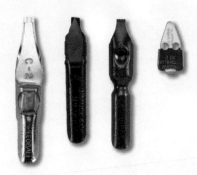

DIP STYLE NIBS

Dip style nibs of any brand have common features. They each have a shaft that fits into the pen holder, the main part of the nib head that has the ink reservoir, and the chisel tip. The chisel tip can be purchased in a wide variety of widths, depending on the kind of letters you'll be making and how big they'll be. Most nibs have the ink reservoir already attached, however some brands, such as the Mitchell nibs, have a small separate piece that slides on to the nib to create the reservoir.

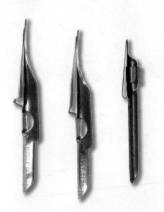

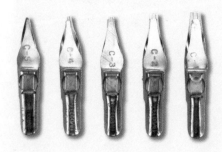

Nib Care

Before using your nibs for the first time, you'll need to clean the manufacturer's grease and varnish from them for the ink to flow properly. You can do this by holding the nib tip in a cup of boiling water for a short time and then wiping it dry, or you can add a few drops of gum arabic to the nib and then wipe it off; no need to rinse.

In between colors or after use, your nib should be thoroughly cleaned with an old toothbrush and soapy water, and patted dry. It's especially important not to let waterproof ink dry on your nibs or they'll be very difficult to clean or use.

Learn more about calligraphy at http://CariBuziak.artistsnetwork.com

Inks

A dip style calligraphy pen can be used with a number of liquid mediums, however most commonly you'll be looking for ink. Ink can be sold by the stick or bottle, and in any color of the rainbow! What ink you choose depends on your project and on what you find works best for how you like to work.

WATERPROOF OR WATER SOLUBLE?

Whether you choose to work in waterproof or water-soluble ink depends on your project.

Water-soluble inks can be good for practice work because you don't have to be as careful about the ink drying on the pen nib, and it's easier to clean up and change colors. Waterproof inks are hard to clean off your nib if left to dry, so are best used for finished work where you need the ink to stay in place no matter what.

INK STICKS

Ink sold in stick form must be liquified before use. This is done against a special stone that has a well in the center. The well is filled partway with water, and the ink stick is lightly rubbed against the stone into the water until the fresh ink has the consistency desired.

PIGMENTED INKS VS. DYES

Inks can be made from pigments, or dyes. Pigments can make the ink feel a little grainy when you write with it because it's an ink made up of tiny particles that give the ink its color. It can also settle out both in the jar (always make sure you shake well!) and on the page, which can give interesting effects if you use a textured paper. Dye-based inks are not lightfast, so will fade over time.

PAINTS AS INKS

You can also use watercolor, gouache or liquid acrylic with your dip pens (use artist-quality or student-grade to ensure strong colors and ease of workability). Each comes in a wide array of colors and opacities, and needs to be thinned before use with your pen. Use a paintbrush to fill the reservoir of your dip pen nib with paint. When using acrylic, always wash your dip pen nib thoroughly after use, or even during use, as the paint dries quickly and can clog your pen.

Cartridge Pen Inks

The ink sold for cartridge style pens is water soluble so it doesn't dry up in the pen and ruin it. Also, because of the fine mechanism within a cartridge style pen that allows the ink to flow, the cartridges contain a dye based ink which can fade. Choose black if you need the letters to last for a long time as the bright colors are the worst offenders for fading!

Papers

There are numerous options of suitable papers to use for calligraphy, depending on your project, personal preference, and budget. The paper you choose can add character or even color to your piece, and can be a source of inspiration for future projects.

PASTEL PAPER

Pastel paper is a light paper that's offered in a wide array of colors. It usually has a smoother side and a textured side, so it's easy to test both and decide which you prefer for your project.

WATERCOLOR PAPER

Watercolor paper comes in different finishes: very smooth (called smooth, or hot press), a medium texture (cold press), or very textured (rough). If your project involves a lot of fine detail and very small lettering, you may want to choose a smoother paper so you're not fighting the texture while adding your details. Textured paper, however, can give wonderful irregular edges to larger letters!

REAL VELLUM

Although a little more costly, real vellum or parchment is a true delight to work with. Made from real calf or deer skin, the translucent nature of the surface makes the letters and colors seem to float above it. There are still a few sources that sell sheets or even full skins of prepared vellum—try a simple search on the Internet.

CALLIGRAPHY PAPER PADS

Paper specifically for calligraphy can be purchased in convenient pads. These are wonderful for practicing on because you have a large number of sheets to work with and they come in a number of different sized pads depending on how big you like to work. As a rule, try to buy a larger pad for practice: 11 x 14 inches (28 x 36cm) or even 16 x 20 inches (41 x 51cm). You'll be able to make nice, large, comfortable strokes as you feel your way around the letters.

HANDMADE PAPERS

Before choosing a handmade paper, always be sure to test it with the style of pen and type of ink you plan to use to make sure the paper reacts properly—some work wonderfully, while others are soft enough to make the ink bleed or clog your pen.

Other Supplies

Basic tools aside, there are a few additional supplies that can be bought if you're really enjoying yourself and want to take your calligraphy further. These items can make it a bit easier to work on larger or more involved projects.

ANGLED BOARD

If you're doing a lot of calligraphy, having an angled board can save your posture! You can purchase a board in plastic, Masonite or wood, or you can easily build your own. Either way, try to get a board that's adjustable so you can change the angle depending on your project or preference.

GRAPHITE TRANSFER PAPER

Graphite paper is one of my favorite time savers! It allows you to trace a design and transfer it to a new sheet of paper. Because it's made with graphite like your pencil, it's fairly erasable, and each sheet is reusable for quite a long time. To use it:

1. Place your good paper on the bottom, a sheet of graphite paper (graphite side down) on top of that, and your original sketch on the top (see photo below).

2. Tape the sketch and graphite layers to the bottom good paper with low tack tape or drafting tape.

3. Use a blue or red medium ballpoint pen to trace over your sketch lines (the color makes it easier to see where you've traced already).

4. Untape your "transfer sandwich" and your sketch should now be ready to ink and paint!

When tracing your sketch onto your good paper, trace just a few lines, then very carefully lift a corner to make sure that it's transferring properly. There's nothing more frustrating than tracing out an entire design only to discover that you had your graphite paper facing the wrong way and nothing transferred! It's also a good way to make sure you're pressing hard enough to transfer the design, but not so hard that you're leaving grooves in the paper.

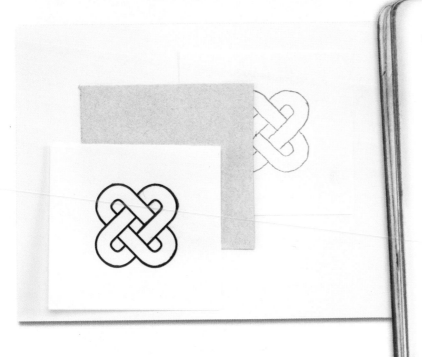

Using a Light Box

A light box helps with tracing and layout. You can rule a bunch of lines for your lettering and place that sheet underneath your good paper as you work so the lines show through without having to draw them on your good paper. You can also assemble many pieces, almost like a collage, lay your good paper on top and then trace the elements that you want to keep onto your good paper. You can buy light boxes, or make your own from a shallow box with a glass top, inserting a long fluorescent lightbulb or two inside. Any large window can also work as a light box.

Adding Color

In addition to the basic supplies, there are a number of fun things that you can use to embellish and add color to your calligraphy projects. We'll cover how to use these different tools more extensively in upcoming chapters.

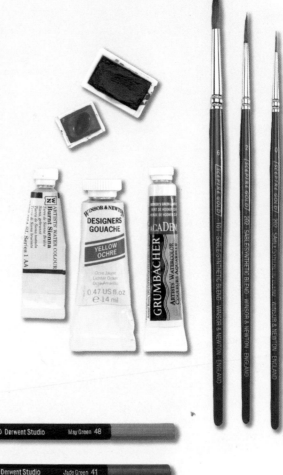

ADDING COLOR WITH PAINT

Not only can watercolors, gouache and liquid acrylics be used as ink, you can use paint to make large colored washes on your background or to add small colored details (you'll want to use artist's quality or student grade paints to ensure strong color and ease of use).

You'll also need a small selection of brushes. I recommend good-quality synthetic brushes in size nos. 0, 2 and 6 to start with. I also use a palette for mixing colors.

ADDING COLOR WITH COLORED PENCILS

Colored pencils can be used to shade in color, draw colored lines, and add fine hairline details in your work. Choose as high a quality pencil as you can afford; better quality gives you a deeper color range and stronger leads and light-fastness. Colored pencils are available in packs or as singles so you can pick the exact shade you want for a project.

WATERCOLOR PENCILS

These are fantastic! If you're worried that watercolors are too tricky to use, then you might want to try watercolor pencils (also known as "water-soluble colored pencils"). These are used much like standard colored pencils, but after you've shaded in an area, take a wet paintbrush and run it over your shading. The water will actually liquify the pencil marks and give it a watercolor appearance. It's a great way to get a watercolor effect, but with more control.

PIGMENTED PENS

I use pigmented pens for all my outlining. As opposed to a regular black ink pen, these are made with a quality pigmented ink that won't fade, is waterproof, and archival. When you're working on a special project and putting that much work into it, you want to use materials that are made to last. Poor quality inks can fade over time, or cause the paper around the ink line to age and make your nice crisp black lines have dirty yellow halos in as little as a few years!

METALLIC AND GEL PENS

Metallic pens can be found in either gel form, or a xylene base (the xylene ones smell and need to be shaken to work as they have a ball inside that keeps the metallic particles from clogging). You can also find gel pens that come in opaque colors and a number of sparkly metallic shades. None of these pens are archival, and so are not appropriate for fine works you wish to be permanent. For a really good project it's better to use a fine brush and metallic gouache for some shimmer, or to gild the area with gold leaf if you want a lot of shine. However, for fun projects that aren't meant to last for a long time, metallic and gel pens offer a quick way to add details and shimmer to your work!

List of Supplies

CALLIGRAPHY PENS

Dip pens and nibs
Cartridge pens
Felt-tip pens

INKS & PAINTS

Pigmented inks
Dye-based inks
Water-soluble ink
Waterproof ink
Ink cartridges
Ink sticks
Watercolor paints (tubes or pans)
Liquid acrylic paints

PENS AND PENCILS

Pigmented pens
Metallic pens
Gel pens
Colored pencils
Watercolor pencils
Sketching pencils in HB, 2B, 2H

BRUSHES

nos. 0, 2, 6 watercolor brushes
no. 0 or 2 round nylon brush

PAPERS

Calligraphy paper pads
Watercolor paper
Pastel paper
Vellum and parchment
Handmade papers

MISCELLANEOUS

Watercolor palette
Vinyl and kneadable erasers
Graphite transfer paper
Angled workboard
Light box
Gold leaf and adhesive size

how to Make Calligraphy Strokes

Many strokes and shapes of letters are similar between alphabets. Keep practicing these stroke exercises and each letterform will become easier and faster to do as your hand gets used to these new movements.

Pen Angle

Every calligraphy hand (or alphabet) is written with the pen nib held at a specific angle. By consistently holding the pen at this angle, the chiseled pen nib will automatically create thick and thin places on each letter, which will give the letter its characteristic look.

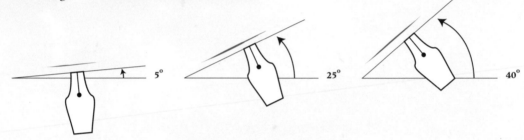

THIN LINES

Hold the pen nib at the given angle and slide it sideways along the thin nib edge.

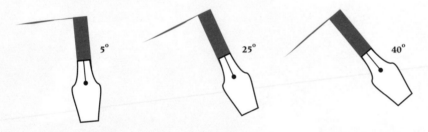

THICK LINES

Thick lines are drawn using the full width of the nib. Try not to rock the pen nib from side to side or it will make irregular edges on your stroke. Keep the nib edge flat on the paper as you write to make a smooth even line.

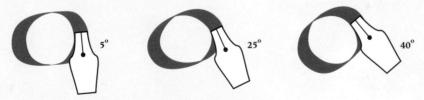

CURVES

Curved lines are also drawn using the full width of the nib. Try to hold the actual pen nib at the same angle and it will make the thick-to-thin changes for you automatically.

Learn more about calligraphy at http://CariBuziak.artistsnetwork.com

Nib Width

Every alphabet has a standard height that it's usually written at, based on the width of the nib used to write it. This is called its "nib width." When you're learning a new letterform you'll be given its nib width, as well as the pen angle, as a kind of formula or guide to writing the letters.

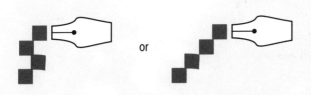

or

MAKE A LADDER

Once you have the nib width, hold your pen nib horizontally and make a series of squares, each offset from the next or stacked in a row. This is called a "ladder." Each square will be exactly the width of your pen nib, hence the name "nib width." Make as many squares or nib widths as you were given for the letterform you're writing.

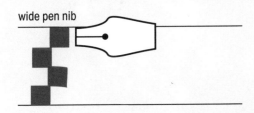

wide pen nib

narrow pen nib

DRAW GUIDELINES

With your nib widths established, use the ladder to draw the writing lines on your page. This ensures that your letters will be the correct proportional height for the letter style and the pen nib you've chosen to write with, regardless of how tiny or enormous your letters are!

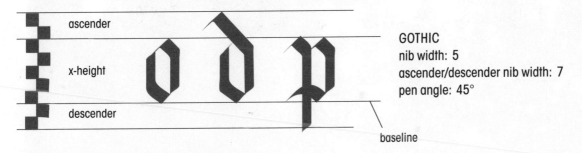

ascender

x-height

descender

baseline

GOTHIC
nib width: 5
ascender/descender nib width: 7
pen angle: 45°

ASCENDERS AND DESCENDERS

A letter has three main parts: the x-height, ascender, and descender. The main body of the letter fills the x-height (for example the lowercase "o"); the ascender rises up above the x-height (the stem of the "d"); and the descender falls below the x-height (the stem on the lowercase "p").

Building Strokes

Each letter in any letterform is made up of a series of strokes. The strokes may be straight or curved, and are usually drawn in a particular order so each subsequent stroke can be landmarked off of the preceding stroke.

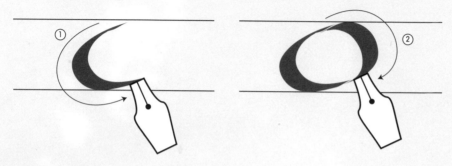

STROKE ORDER

When following the examples in this book, draw your letters using the numbered arrows as construction guides. Starting at arrow no.1, draw the stroke as shown from start to finish. Then draw arrow no. 2, and so on.

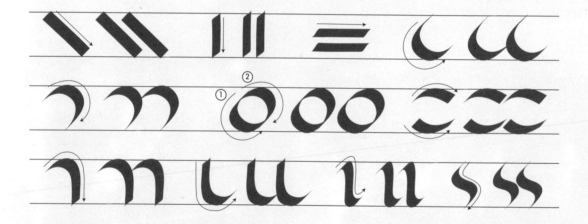

PRACTICE STROKES

There are a number of basic strokes and shapes that make up most letters. These can be used to practice your pen control and also make a great warm-up when you first sit down to a calligraphy session! Unless you're practicing a particular letter style, you don't need to worry about which nib width or angle to use.

Learn more about calligraphy at http://CariBuziak.artistsnetwork.com

Letter Construction In Depth

Let's begin with some "Uncials" to practice our strokes and to see in-depth how a letter comes together. We will examine more alphabets and additional letters in the next chapter, but let's take a few sample letters here and really break it down.

Mark four nib widths on the upper left hand corner of your page and use these to draw a pair of writing lines. Mark an additional one nib width above and below these lines to mark where our ascenders and descenders will extend to.

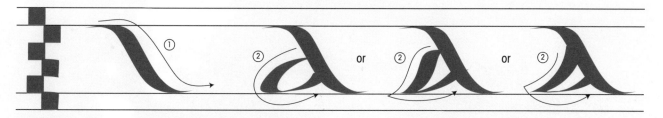

LETTER "a"

1 Holding your pen nib at an angle of 5 degrees, begin this stroke with a very small slide of the pen nib along the thin edge, pull it downward at an angle, and then finish with a tiny slide along the nib edge.

2 The second stroke begins about halfway down the previous stroke and makes a small loop or oval to finish our letter "a." If you like, you can make variations on this bottom loop by changing the shape of the second stroke to give your "a" some personality.

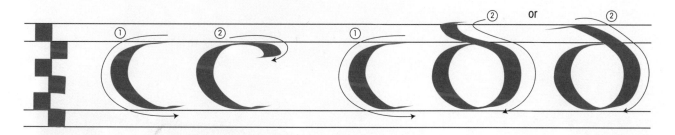

LETTER "c"

1 The first stroke of the letter "c" is used as the first stroke of a number of letters. It is essentially a smooth curve from top to bottom, ending in a nice taper.

2 The second stroke begins with a slide to the right and finishes with a small downward pull to make the cap.

LETTER "d"

1 The "d" begins the same as the letter "c."

2 The second stroke begins with a small slide to the left and then sweeps around to meet with the bottom of the first stroke. This second stroke can also be made as just a large curving sweep down to the bottom of the first stroke.

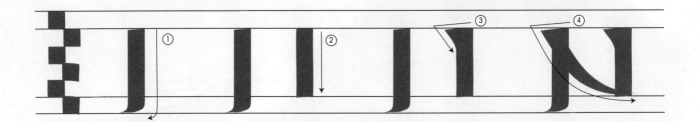

LETTER "N"

1 The letter "N" begins with a simple downward stroke, extending slightly past the line and ending with a small slide to the left. If you prefer a more modern look to the "N," you can end it right at the baseline and omit the small slide at the end.

2 The second stroke is a straight line, ending at the baseline.

3 The letter "N" has serifs in its construction, which in the Uncial alphabet is a strong wedge on the top lefthand side of straight strokes. For our third stroke we will add a small wedge to the top of our second stroke: slide the pen a little way to the left from the top of the second stroke, and then bring it in to rejoin the vertical stroke.

4 Begin your fourth stroke with a slide to the left from your first stroke, and then sweep it down to meet the bottom tip of the second straight stroke to finish the letter.

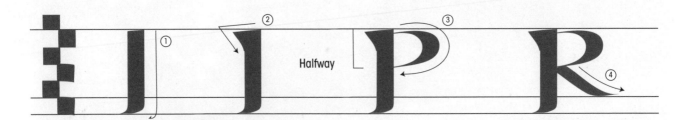

LETTER "R"

1 The letter "R" begins much like the "N" did, with a straight stroke extending past the baseline.

2 Because this is a straight line, we're going to add a wedge serif to the top.

3 The bowl of the "R" should come to at least the halfway point in the x-height, or even further down for a nice, fat curve.

4 The last leg of the "R" kicks out from below the curve and ends at the baseline.

You can see that many letters are made using the same strokes as in previous letters, in a way recombining them to create the new letter. This is true with all alphabets that you'll learn, which makes it easier to master a new letterform and gives you a guide to check against as you work on new letters. You'll know that often the "O" shares characteristics with the "C"; the "V" and "U" share characteristics with the "W"; the "M" shares with the "N," and so on. Use this to spot the similarities between letters you have already practiced and the new ones you tackle, and this will help keep your letters consistent.

 Learn more about calligraphy at http://CariBuziak.artistsnetwork.com

Lettering Terms

Here are some additional terms used in calligraphy that are helpful to know before you begin working on the different alphabets.

MINUSCULE

Minuscules are the lowercase letters in an alphabet. Some miniscule letters lend an informal look to a piece of text, and can be used in projects where a lighter or more inviting feel is desired.

MAJUSCULE

Majuscules are the capital or uppercase letters in an alphabet. They're great for creating a splash at the beginning of a text with a larger or more detailed letter, monograms, or a detailed piece in stand-alone uses where there may not be any other text or designs in a project.

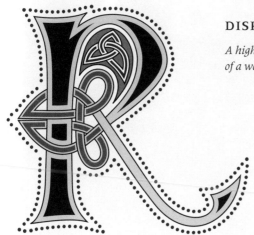

DISPLAY CAPITAL

A highly decorated Majuscule used at the beginning of a word or sentence is called a Display Capital.

CURSIVE

A more fluid or script style of writing, cursive was developed as a faster way to write by monks. It usually has a looser and less formal look. Cursive is useful for projects needing letters that flow and move in the design without looking too formal or stiff.

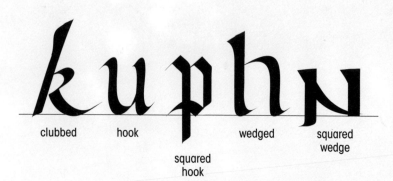

clubbed hook wedged squared
 wedge

 squared
 hook

SERIF

A serif is a small stroke at the beginning or end of a main stroke. A serif can be made in many ways and often gives a particular alphabet its characteristic look.

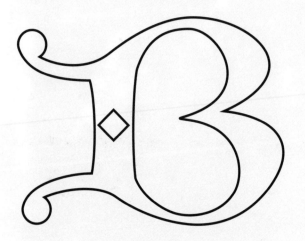

BUILT-UP LETTERS

A built-up letter is created by drawing the strokes by hand, rather than with a broad nib. The letter is essentially "built" by a series of hand drawn lines.

Learn more about calligraphy at http://CariBuziak.artistsnetwork.com

Letter Spacing

Have you ever typed out a word on your computer in a fancy font, and the letters were spaced out funny? When a font is made, the computer calculates what the average distance will be between letters as they're typed. A well-made font anticipates problematic combinations such as "TI" and "AT," whereas a poorly made font can leave too big of a gap between a pair of letters and make a word look broken and choppy when read. With calligraphy, you're writing a series of letters manually and you need to plan where your letters are going to go so when you write your word or sentence, there are no unusual gaps or too-tight places.

WELL-SPACED LETTERS

Here the letters are evenly spaced yet are close enough to relate to each other and form a word, without being crowded too closely. The letter "g" which is shaped uniquely compared to the rest of the letters, is slightly nestled underneath the preceding "r" and hugs the "e" closely.

TOO MUCH SPACE

Although evenly spaced, the letters in this example are too far apart. The letters don't work together, but instead stand too isolated from each other, making it more difficult to read.

IRREGULAR SPACING

Make sure not to leave an irregular gap between a pair of letters or it will make a visual "hole" in your word. It can be helpful to write your word(s) out on a test sheet to plan for letter spacing both between the letters in your words as well as between the words in a sentence. This plan can then be posted in your workspace while completing your final piece, or used as a guide underneath your paper if you're working on a light box. Your spacing sample will show through and give you a guide to follow when writing your good text.

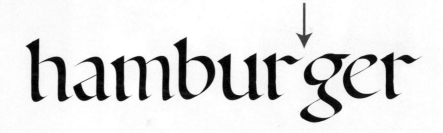

15 Alphabets From Basic to Fancy

These fifteen alphabets are arranged by difficulty, but don't let that frighten you! Remember that a letter is nothing but a series of strokes. If your pen angle remains constant and you take the time to draw each stroke in the order given, you can accomplish any of these alphabets. Don't worry if your strokes wiggle or your vertical lines are slightly off kilter—these things will improve with practice. Take your time and soon your letters will look more uniform and you'll be making your own beautiful cards and projects!

Foundational

Created by Edward Johnston, the Foundational hand is based on the Ramsay Psalter, a 10th Century manuscript. The letters are clean, very readable, and not overly formal nor casual, making them suitable for a wide variety of projects and a great beginner hand to learn.

30°

FOUNDATIONAL
nib width: 5
ascender/descender nib width: 7
pen angle: 30°

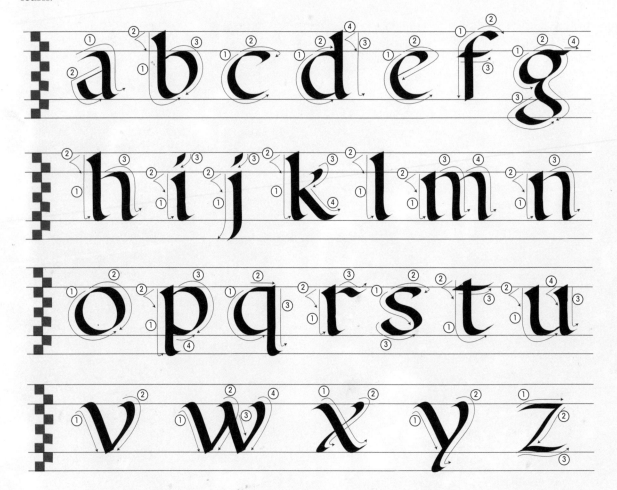

Foundational Majuscule

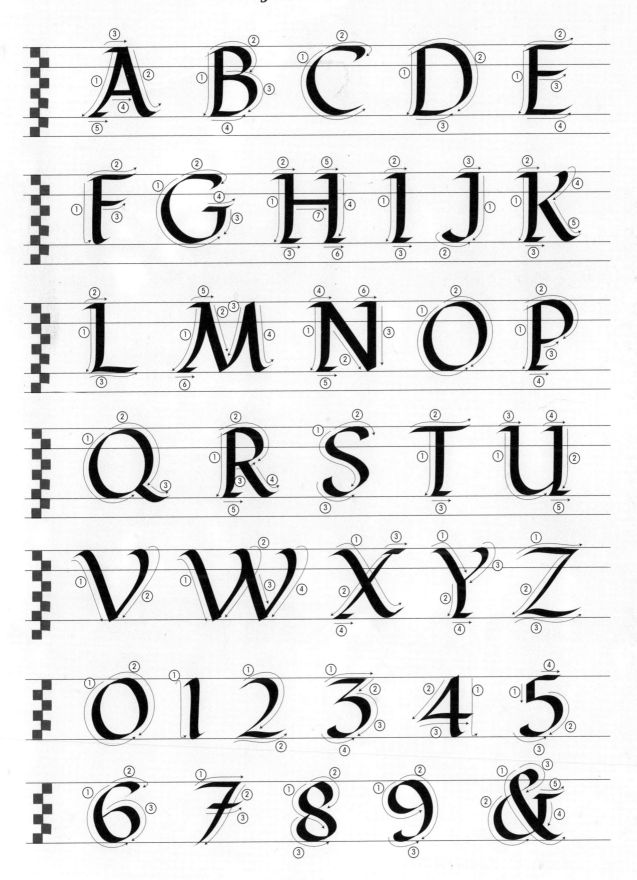

Carolingian

Carolingian Minuscules are named for Emperor Charlemagne, who promoted the written word through numerous manuscript commissions. Ironically, he himself didn't know how to write! This hand is a true minuscule hand in that it has no matching uppercase. Instead, use Roman, Uncial or Versal letters (see pages 30, 31 and 40) as your uppercase.

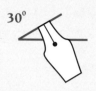

CAROLINGIAN MINUSCULE
nib width: 3
ascender/descender nib width: 8
pen angle: 30°

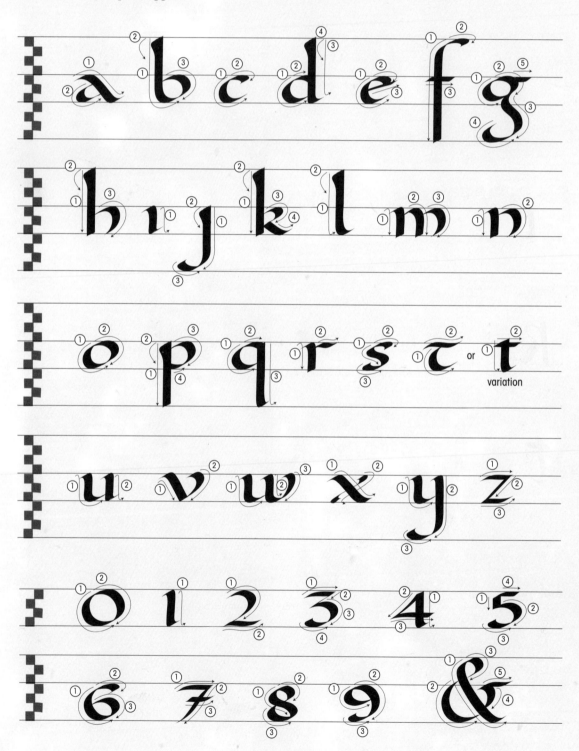

Learn more about calligraphy at http://CariBuziak.artistsnetwork.com

Italic

Originating in Italy in the 15th Century, Italics are a wonderfully expressive hand and lend themselves well to formal uses. The basic letters have romantic sweeps that can be further embellished into beautiful swashes. Italics are written with a 5-degree slope or slant to all the letter stems.

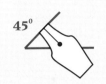

ITALIC
nib width: 5
ascender/descender nib width: 8
pen angle: 45°

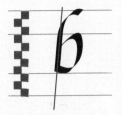

There's a 5-degree slant on all stems in Italic.

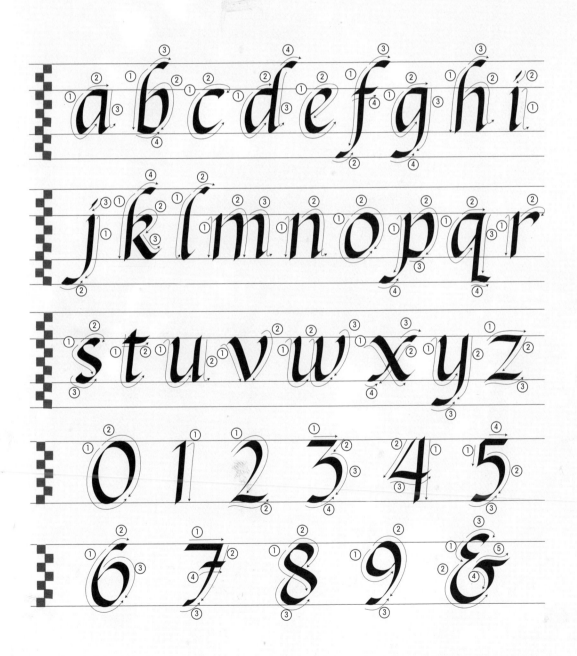

Italic Majuscule

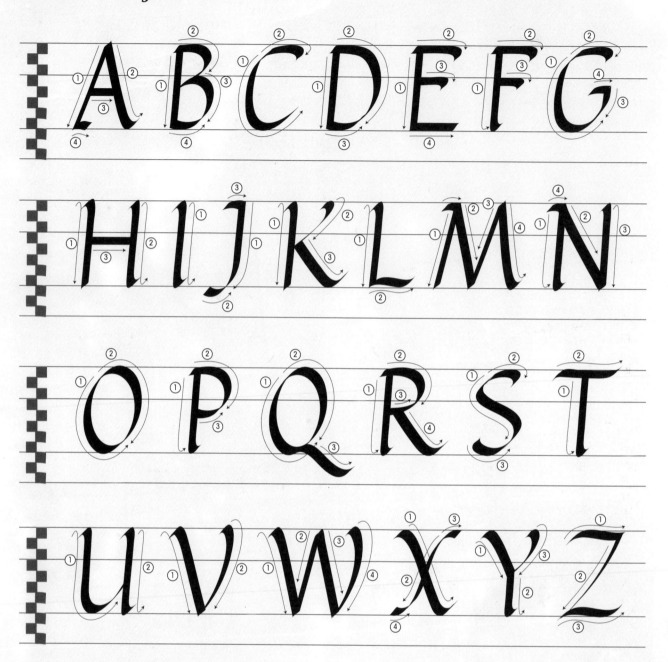

Learn more about calligraphy at http://CariBuziak.artistsnetwork.com

Italic Swash Majuscule

Italic capitals ("majuscules") can also be written with incredibly decorative swashes, adding an ornate quality to the letters. These letters should be used only as capitals at the beginning of words and names, as an entire sentence written in them would be difficult to read.

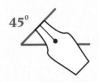

ITALIC SWASH MAJUSCULE
nib width: 8
pen angle: 45°

There's a 5-degree slant on all stems in Italic.

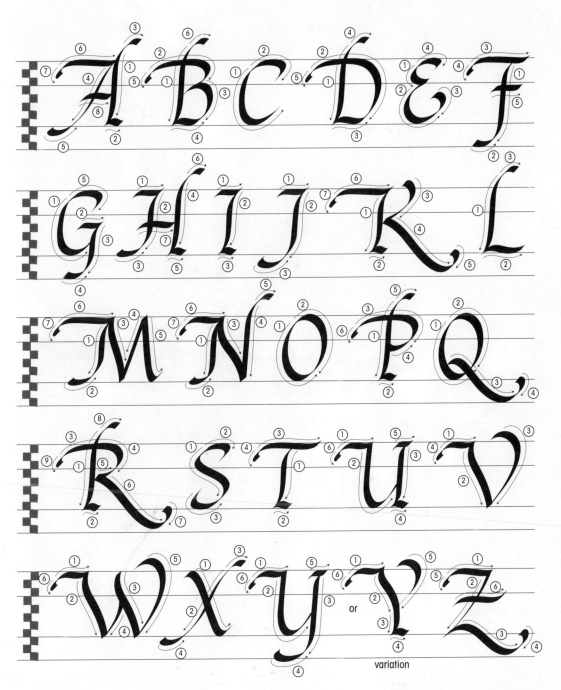

variation

Roman

Roman capitals were originally developed by ancient Roman stone cutters and cut with a chisel and mallet. Their look is very traditional and straightforward, with no overly decorative swashes. There is one small trick to accomplishing some of the serifs: keep one point of the pen fixed and pivot slightly on that point to pull the serif out.

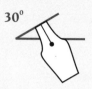

ROMAN CAPITALS
nib width: 7
pen angle: 30°

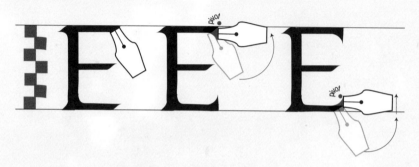

1 Keeping the top nib corner planted on the paper, pivot the nib on that corner to pull the serif out.

2 As the nib is pivoted for a bottom serif, the nib can slide slightly upwards to keep the bottom line level with the horizontal line.

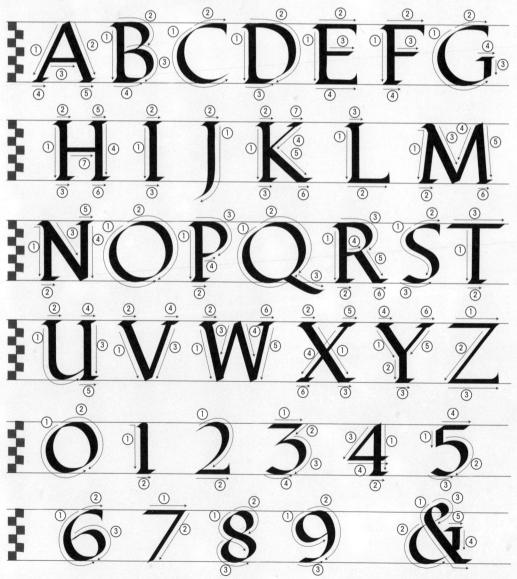

Learn more about calligraphy at http://CariBuziak.artistsnetwork.com

Uncial

Uncial letters originated in the 2nd Century and are a very readable letterform, making them suitable for large blocks of text. Their slightly formal appearance also makes them a good choice for seasonal and holiday projects.

5°

UNCIAL
nib width: 4
ascender/descender nib width: 5
pen angle: 5°

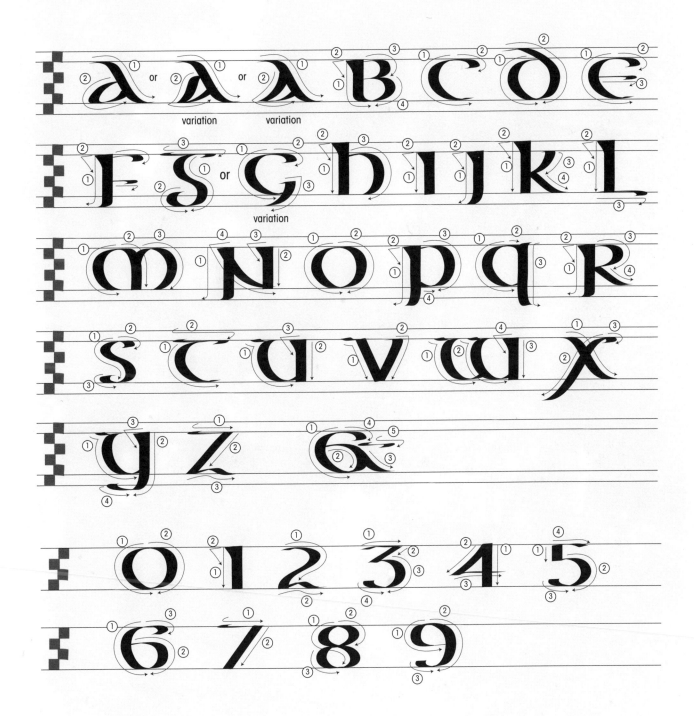

Modern Half-Uncial

The Half-Uncial letterform developed in the 8th Century and can be seen in the famous Irish manuscript, the "Book of Kells." These modernized versions are characterized by fat round letters and thick serif wedges. These letters can be paired with decorated Versal capitals to create ornate yet readable works.

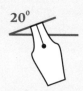

MODERN HALF-UNCIAL
nib width: 4
ascender/descender nib width: 6
pen angle: 20°

Learn more about calligraphy at http://CariBuziak.artistsnetwork.com

Gothic

Gothic is probably one of the most easily recognized of all the lettering styles. Originating in the 12th Century, its heavy, angular strokes and tightly packed letters were used for manuscripts and formal documents for a number of centuries, and is still used today for similar works. The finished product can be difficult to read so should not be used when legibility is essential.

GOTHIC
nib width: 5
ascender/descender nib width: 7
pen angle: 45°

Letter spacing is equal to approximately 1 stroke width.

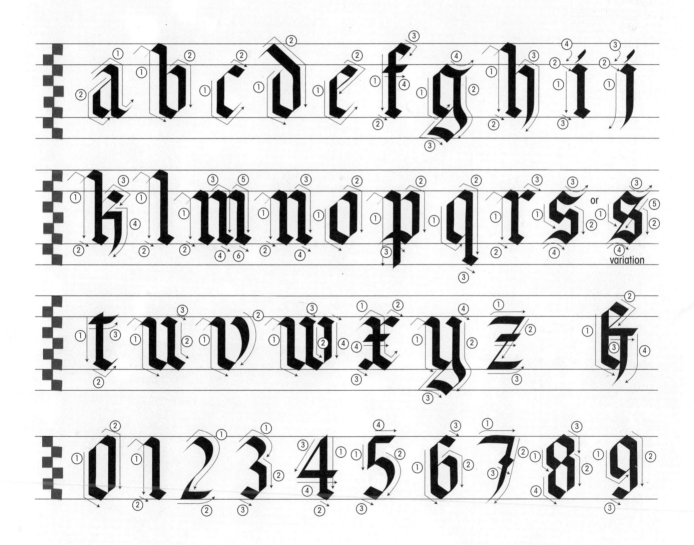

Gothic Majuscule

These beautiful Gothic uppercase letters have a similar construction to the lowercase, however there are some fine manipulations with the corner of the calligraphy nib to create the curls and flourishes. Add the decorative diamonds last after the rest of your strokes. These capitals are also perfect for use as initials and monograms in projects, but due to their ornate nature you would never use all Gothic uppercase letters to make a sentence.

GOTHIC UPPERCASE
nib width: 6
pen angle: 45°

1 Draw the main body of the stroke, then return to the starting corner. Using the corner of your nib, pull some of the wet ink into a small curl.

2 To draw an end curl, use the corner of the nib to draw a small curl at the end of the stroke.

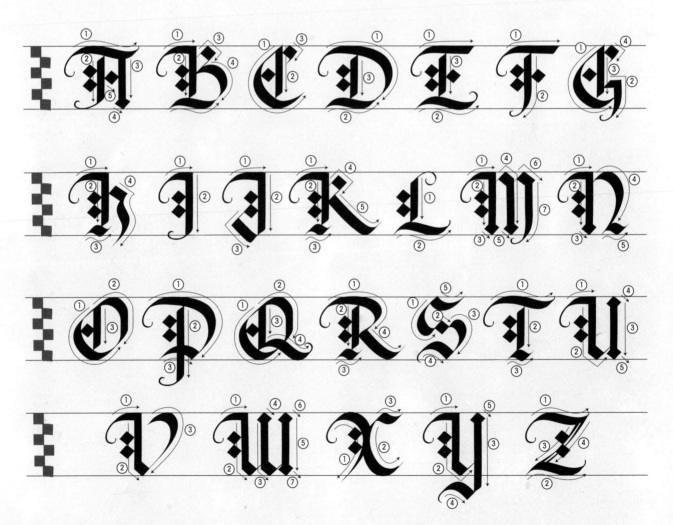

Learn more about calligraphy at http://CariBuziak.artistsnetwork.com

Gothicized Italic

This Gothicized Italic letterform has the formality and density of traditional Gothic, however the Italic influences give it more verve and flair. The roundness of the letters also makes it more readable in longer texts than Gothic would be, making it suitable for semi-formal to formal works that need to be legible.

GOTHICIZED ITALIC
nib width: 5
ascender/descender nib width: 7
pen angle: 45°

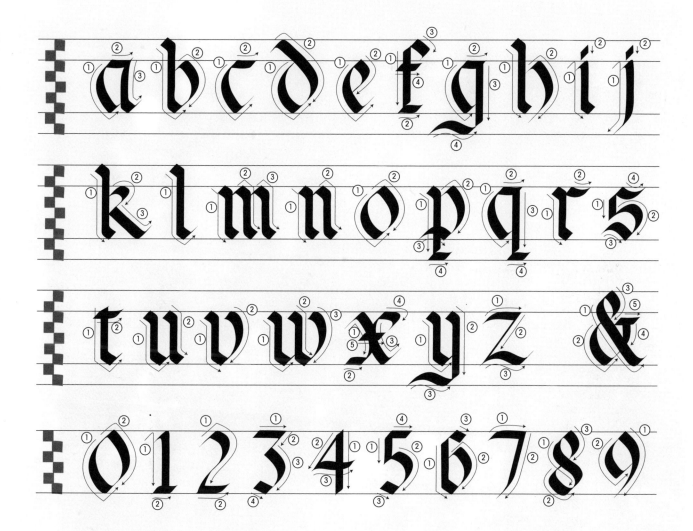

Gothicized Italic Majuscule

The uppercase for Gothicized Italic is actually a Gothic uppercase variant, so would be suitable for use with that letterform as well. The tip of the calligraphy nib is used to draw the flourishing curls, and the edge of the nib is used to draw the thin lines.

GOTHICIZED ITALIC UPPERCASE
nib width: 6
pen angle: 45°
diagonal stroke angle: 30°

1 Keeping the top nib corner planted on the paper, pivot the nib on that corner to pull the serif out.

2 Hold the pen nib at different angles to complete the hairline strokes. Add these details last.

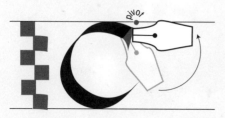

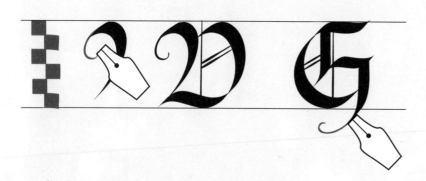

3 Draw the main body of the stroke, then return to the starting corner. Using the corner of your nib, pull some of the wet ink into a small curl. To draw an end curl, use the corner of the nib, draw a small curl at the end of the stroke.

Learn more about calligraphy at http://CariBuziak.artistsnetwork.com

Gothicized Italic Majuscule

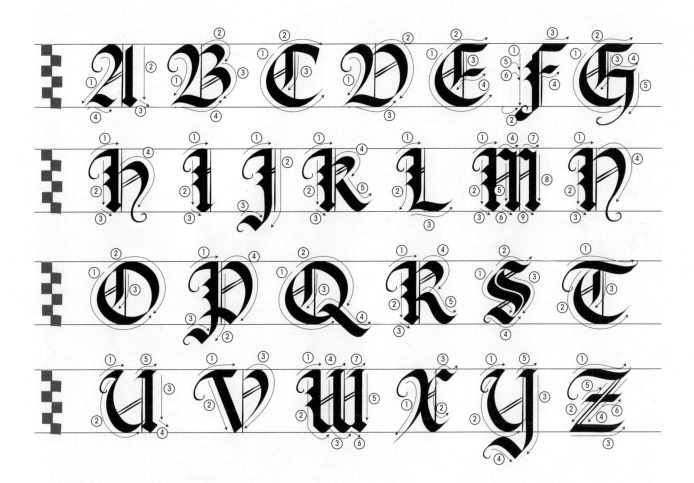

Batarde

Batarde is a Gothic cursive hand, with a whip-like stroke and decorative curls made with the corner of the pen nib. These letters have attitude and are great for use with a passionate expressive text.

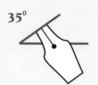

BATARDE
nib width: 4
ascender/descender nib width: 6
pen angle: 35°

The "f" and "p" in this letterform require a bit of pen manipulation to get the downward stroke. Begin with your pen nib at a 35-degree angle and pull downward. As you slide the nib down, twist the pen slowly so the line tapers neatly.

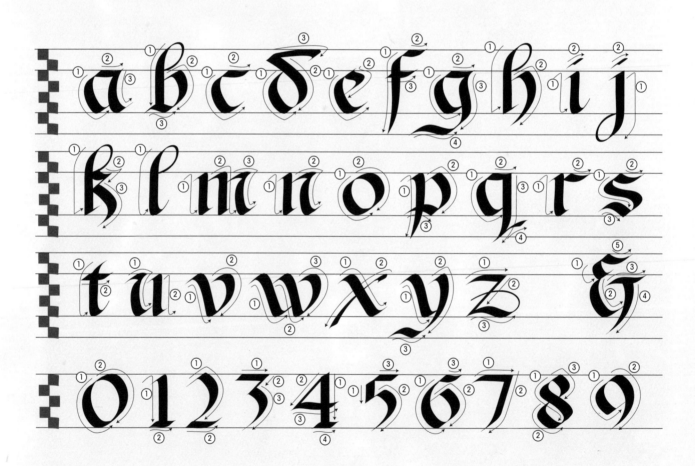

Batarde Swash Majuscule

This uppercase used for Batarde could also be used interchangeably with the lowercase Gothic or Gothicized Italic letters. The swashes in this uppercase need a lot of room to breathe, so a generous x-height should be used. The diamonds are drawn with a 45-degree pen angle to make them a bit heavier. These and the hairline strokes should be added to your letter last. I have colored the stroke direction arrows for these to make them easier to see with the complex lettering.

BATARDE UPPERCASE
nib width: 10
pen angle: 35°
diamond pen angle: 45°

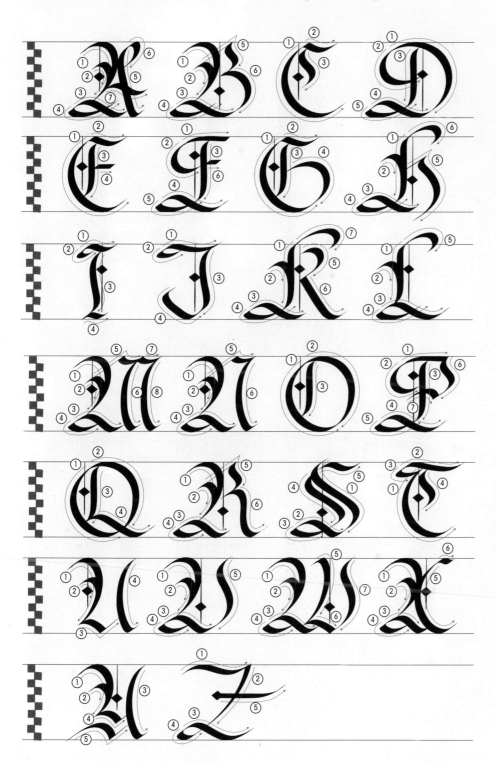

Versals

Versals are not like normal calligraphic letters. Instead of using a pen nib to define your thicks and thins, versals are drawn in pen or pencil as outlines and then filled in with black, a color of your choice, or gilding. Traditionally they were used to begin sentences or verses (hence their name), and because they're so ornate they should be used sparingly in a piece. I have defined a nib width for the x-height and ascenders as a reference point and guide. Stroke order is not important with these letters.

VERSALS
nib width: 5
ascender/descender nib width: 6
pen angle: none

A B C D E F G
H I J K L M N
O P Q R S T U
V W X Y Z &
0 1 2 3 4 5
6 7 8 9

Learn more about calligraphy at http://CariBuziak.artistsnetwork.com

Lombardic Versals

Lombardic Versals would be used in the same manner as plain Versals, however they're a more decorated variation. The decorations added to the tips of the hairlines can be made in a number of ways, or make up your own! As with plain versals, stroke order is not important.

LOMBARDIC VERSALS
nib width: 5
ascender/descender nib width: 6
pen angle: none

Note: The decorated hairlines can end in any number of designs. Here are some ideas but feel free to make up your own!

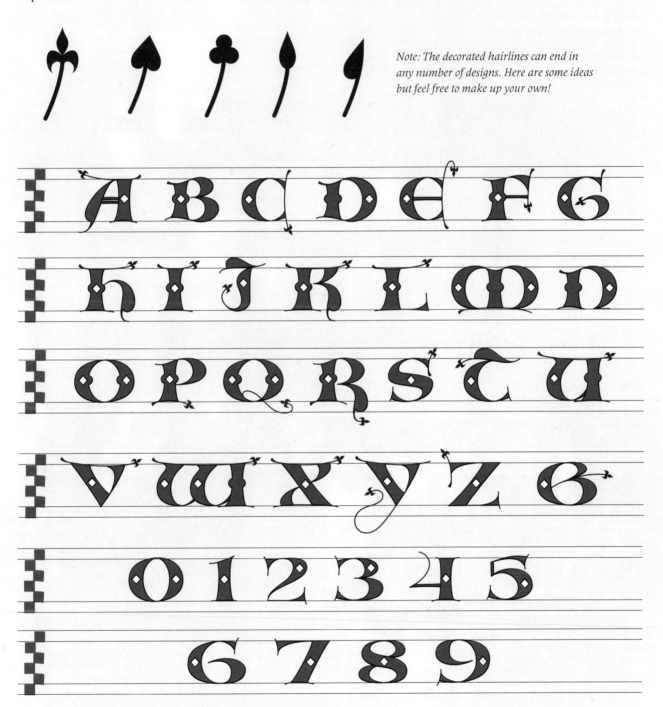

Ornamentation, Gilding & Coloring

While calligraphic letters are beautiful enough on their own to create stunning pieces of art, for some uses you may want to add a bit of embellishment. Illustrations, color and historical details like Celtic knotwork can add a bit of spice to your project, personalizing it and adding interest to an otherwise blank area. In this chapter we'll cover some easy ways to add these details, which can really enhance your project!

Celtic Knotwork

One of the most identifiable designs in Celtic art is the "knotwork interlace." Designs are drawn to look like woven braids, and are very suitable to use as focus designs in a project, borders, and background patterns. I find that one of the easiest ways to build nice, consistent Celtic knots is to use "dotted" graph paper. This creates an even guide to follow as you plot your knot. Dotted graph paper is easy to make from any store-bought graph paper by taking a marker and bolding every second dot, or using a computer graphics program.

I have included at the back of this book a couple of sheets of ready-made dotted graph paper for you to make your first Celtic knots. But if you need to make your own, it's easy!

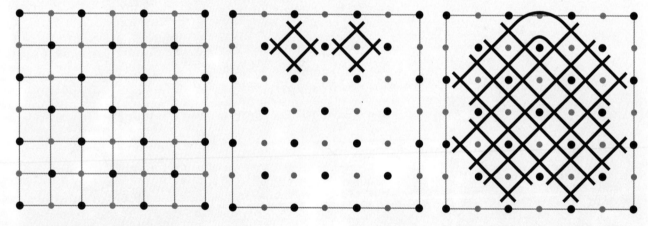

1 Start with a sheet of standard graph paper. Using different colored markers or pencils, alternate coloring 1 big bold dot and 1 smaller dot all across the page of graph paper at every intersection. Once the whole sheet is covered, make some photocopies. That way you'll always have a supply ready to go!

2 To keep things clear, I will show only the dots in the step-by-step photos from here on and not the lines of the graph paper. Make a box around a portion of your graph paper, at least 4 big dots across and down. Your corners must always be on a big dot. Put a double lined "X" (like a tipped over tic-tac-toe board) over each little dot inside your square. Do not cross any little dots that lie on your border, just the ones that lie inside.

3 After you've made an "X" over every little dot in your marked-off area, start to join the knot lines along the sides, top and bottom. Find where two lines branch out from the body of the knot, angling toward each other. Make a double-lined bend like an elbow to connect them.

Celtic Knotwork

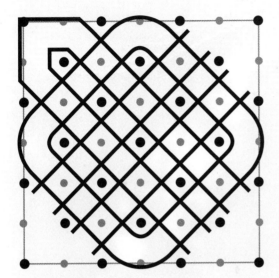

4 Now all the loose ends on the knot should be joined, except for at the corners. Add the caps on the corners of the knot.

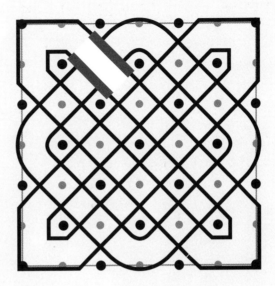

5 Next we will make the lines of our knot weave. Each line as it interlaces must go over, and then under, any other line it intersects as you follow its path in an "over-under-over-under" pattern. No areas of two overs or two unders in a row! To start your over/unders, pick any point of intersection on your knot. At this intersection (shown here in red), erase part of the double lines of one of the knot "ropes" to create the illusion of one rope passing over the other.

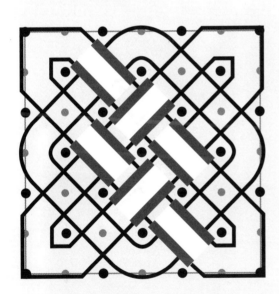

6 Continue to follow that one rope of knot, erasing as you go, alternating whether it goes over or under the next rope it meets. When you reach the end of that rope's path, pick a remaining unerased intersection and look at the other ones around it. If the rope leading into the intersection has just come from under another rope, you need to erase your lines so it now passes over this one. Continue in your over-under-over-under pattern.

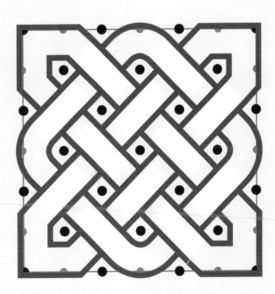

7 When all your overs and unders have been woven, you're finished with your basic Celtic knot!

Knotwork Variations

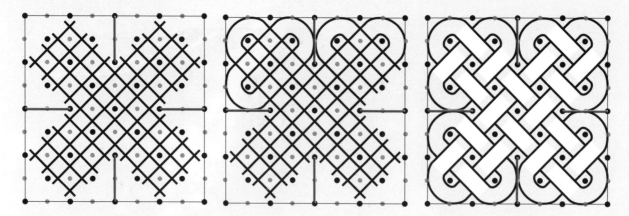

ADD COMPLEXITY

More complex knotwork patterns can be created by adding "walls" (shown above in red) within your boundary square. All the construction techniques remain the same: add "X's" over the small dots, add elbows and corners, then weave. The one differ-

ence is that you do not add X's over the little dots crossed out by the walls. Instead, add more elbows and corners as the knotwork lines "bounce" off the walls.

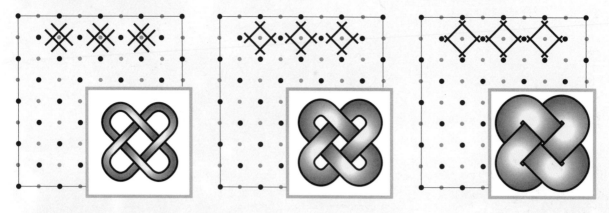

VARY THE THICKNESS

To give your knot personality, you can vary the thickness of the knotwork "ropes" by making your tic-tac-toes skinnier or fatter. Making the tic-tac-toes skinny and close to the little dots (above left) will give you a thin knot with lots of background showing behind

the knot. The fatter the tic-tac-toes and the further away they are from the little dots, the wider your knotwork ropes will be and the less background will show through the holes in the knot.

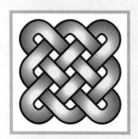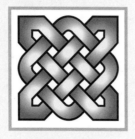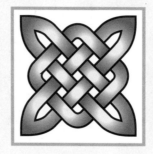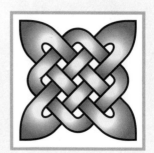

STYLE THE CORNERS

You can also change the look of your knot by changing the style of the corners. Choose all the same corner styles in one knot, or mix and match!

Learn more about calligraphy at http://CariBuziak.artistsnetwork.com

Background Patterns

Using a background pattern behind a letter or word can add a bit of extra detail and interest, as well as some interesting elements to which you can add color. There are a number of traditional patterns that can be done, based on simple geometric shapes.

The checkerboard is the easiest pattern to create; however, the boldness of the squares can overshadow your foreground element. By varying the size of the checkers, or the colors used, you can tone the pattern down and keep it in the background.

Here the checkerboard background is too strong and makes it difficult to see the letter.

USE COLOR AND SCALE

To make your foreground letter stand out, vary the colors of the checkerboard or change the scale of the pattern. The blue and black checkerboard squares are half the size of the green and white ones.

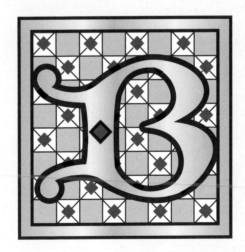

ADD DETAILS

This pattern is easy to create from the basic checkerboard and makes a finely detailed background that shows off a foreground element nicely.

Create a Basic Checkerboard

This background pattern (shown in color on page 45) is based on a basic checkerboard with a simple embellishment added.

1 Start by drawing a diagonal line through every other square, beginning at the very corner of the first square in the upper left corner.

2 Draw across the diagonal lines in the same squares, but from the other direction.

3 Add a tiny solid square at every intersection of these diagonals.

This pattern is also based on the basic checkerboard. It has an almost stained glass effect if the triangles are all colored in various shades of the same color.

1 Starting at the other corners of the first square this time, draw a diagonal through every other square.

2 Create a matching diagonal going in the other direction.

3 Add a tiny open square at every intersection of these diagonals.

Learn more about calligraphy at http://CariBuziak.artistsnetwork.com

Vines

Vines are a wonderful way to add a bit of texture to a design. They can be used as a border, within a letter, or in the background of a capital letter or monogram. The key to natural looking vine curls is to keep reversing the direction of the curl and to change the size of the different curls so they don't look too mechanical.

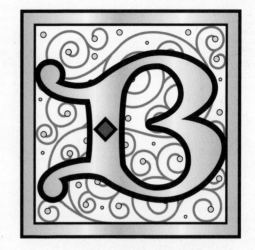

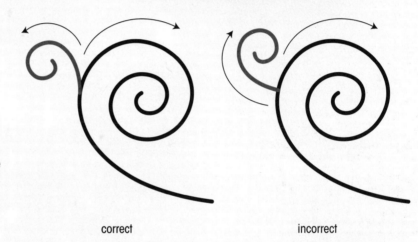

correct incorrect

1 Start your vine with a curl. This first curl should be fairly large and will be the main "parent" stem from which the others will begin branching.

2 Now begin adding smaller, "child" branches coming off the parent stem. These child branches, shown in red, should curl in the opposite direction to the parent. For example, if the parent curls clockwise as we see above left, then its children should branch counterclockwise.

3 To create complex vine clusters such as the one shown in the blue background of the letter "B" at top right, begin with a large parent curl. Add a child curl in the opposite direction somewhere along its path. Here the parent curls counterclockwise, so the child should curl in the clockwise direction.

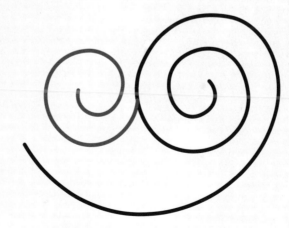

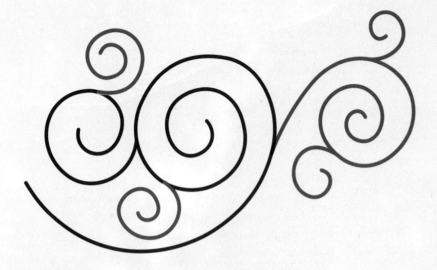

4 Continue to randomly add more child curls to the parent, slowly filling up the empty space. When adding curls to the child curls, again reverse the direction so the "grandchild" curls are opposite to the child curl they spring from. Vary the tightness and size of the curl to add more randomness to the pattern.

6 Compare the unadorned vine cluster at left to the one in the background above. It's the exact same design, but do you see how adding color to it makes the letter "B" stand out? Note that the "berries" are the same yellow color as the letter B. Any ornamentation or embellishment you add should complement your main element, never distract from it or overpower it.

5 In this vine cluster, notice how the main parent stem (shown in red) changes direction in the center. Child curls springing off this main stem still curl opposite to it, springing clockwise from the counterclockwise parent half, or counterclockwise from the clockwise parent half. Small dots or "berries" have been added to the curls to add detail.

Learn more about calligraphy at http://CariBuziak.artistsnetwork.com

Leaves and Flowers

Flowers and leaves are an excellent way to add some life to a design, especially if you're using vinework. You don't have to be an artist to draw these; there are many simple ways to create them and use them in your project!

Generic Leaf

1 This leaf style is useful because it could belong to any flower or plant. Begin with a curved side.

2 Add a second side, making it flow outwards and then in again to a nice point at the tip.

3 Add a vein down the center. The vein should curve the same way as your very first line to give the leaf its shape.

Ivy

1 Start your ivy leaf with two rounded humps.

2 Come in a little from each end, and then make a point on either side

3 Join them with a third point, and add three veins within the leaf to finish.

Heart Leaf

This leaf has a romantic flair because its shape is based on a heart.

peak upwards

1 Begin by drawing a heart, but instead of the heart indenting "down" at the top, it should peak upwards.

2 Add some veins to the leaf.

3 If you want to add a little more color, the veins of your leaf can be stylized as wedges instead.

Art Nouveau Flower

1 Begin with a circle, then add a crescent shape on one side.

2 Add a second crescent on the other side, slightly tucking one end of the new crescent under the old, and leaving the other end out.

3 Add another pair of curves perpendicular to your original ones.

4 Add more curves to divide up the center even more, always adding the new curves approximately perpendicular to the previous pair.

Learn more about calligraphy at http://CariBuziak.artistsnetwork.com

Rosebud

1 Begin with a pair of teardrops that overlap at the base.

2 Add a pointed shape above.

3 Add a pair of curves to the bud to create the look of tightly closed petals.

4 Your bud can also be given a rounder shape and then the petals shown as a tight curl near the top.

Other Simple Flowers

Around a circular center, draw five repeating heart shapes.

Freehand some loose loops around a center for a whimsical daisy.

Create a stylized flower from plain curves around a circular center, then add simple leaf shapes if you wish.

Birds and Butterflies

In ancient manuscripts, monks used to hide tiny birds and insects within their calligraphy and illuminations. Here are some simple ways to create your own fanciful creatures to hide in your work!

Singing Bird

 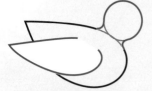 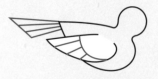 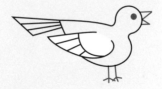

1 Begin with a teardrop shape for the bird's body.

2 Add a circle for the head, smoothing the join from the head to the body. Add another teardrop shape to the side of the body for the wing.

3 Add the wing feathers and tail feathers.

4 Finish with the eye and beak, and some little feet!

Bird Variations

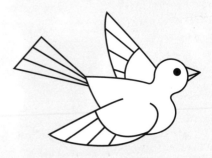 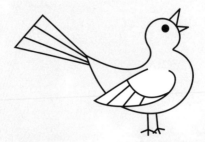 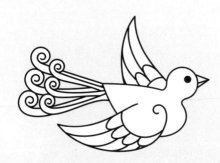

A flying bird is created much the same way, but make the wings a bit larger and angle them out from the body. By lifting the tail and not drawing the feet, he looks like he's taking flight!

By curving his chest up and out more, tilting his head back and lifting his tail, he takes on a perky appearance like a spring robin bursting into song.

Add more details to his feathers for a fantasy flourish.

By changing the shape of the beak and the size of the eye, you can change him from a songbird to a parrot!

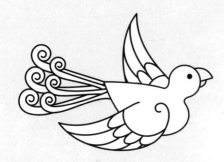

Learn more about calligraphy at http://CariBuziak.artistsnetwork.com

Butterfly

1 There are so many variations you can make with butterflies! Begin with a body made of two long segments.

2 Add wings to either side. The wings may be continuous wings or two-part wings of any shape.

3 Add simple designs like dots, diamonds and teardrops within the wings to decorate them. Add two curling antennae and he's done!

Gilding

Gilding is a wonderful embellishment to add to your calligraphy projects. A sheet of the very thin metal used to gild is called "leaf." There is gold leaf, silver leaf (both in imitation and real), as well as copper leaf and fancy variegated leafs that change colors. Gilding, the process by which you add leaf to a project, adds sumptuous sparkle and shine and is very easy to do.

The process of gilding is essentially the same no matter which type of leaf you're using. There are traditional ways to gild using gesso and burnishing tools; however even a beginner can achieve great results without having to buy expensive tools or use temperamental gesso. So in this lesson we'll be using synthetic "adhesive size," which is a kind of glue that dries sticky.

Synthetic adhesive size is waterbased and cleans up with soap and water. I use an inexpensive nylon brush just for leafing because I find that the size leaves a bit of residue behind, so after twenty or thirty uses I just throw the brush out when it becomes too gummed up.

Materials Needed

Synthetic adhesive size

No. 0 or no. 2 round nylon brush

¾-inch (19mm) or 1-inch (25mm) soft brush (inexpensive goat hair brushes work well)

Package of leaf (real or synthetic, gold or any other metal)

Tip

If you're working on white paper it can be difficult to see where you have applied your adhesive size. Try adding a tiny touch of watercolor or gouache to your size to tint it. That will make it easier to see where you've been and the tiny addition of the watercolor won't affect the size. A traditional color to add to size for gold leafing is a red-orange watercolor like vermilion.

1 Paint the Adhesive Size

Paint the adhesive size anywhere you want the leaf to stick. Although the instructions say not to let the size settle into puddles, when I'm painting a design on a very absorbent surface like watercolor paper I apply the size more thickly (as some of it will soak in) or apply it in a few layers. The size will take about an hour to dry, and will turn from a milky white to clear. If you're having trouble seeing where you've painted the size, try tinting it with a touch of watercolor, as I did here.

2 Lay the Leaf

Sometimes the easiest way to handle leaf is to cut the binding holding the tissue pages together as a booklet and carry the sheet of leaf across in a tissue "sandwich" (two sheets of tissue with the leaf in between). Pull a little of the bottom tissue back from the leaf and touch the exposed leaf to the size. The leaf will stick and you can pull the rest of the tissue away and let the leaf float down to the rest of your surface (a dry paint brush can help "direct" the leaf down smoothly). All leaf is very light and flies away easily, so wherever you gild, be sure it is free of drafts!

3 Ensure Coverage

Pat down the leaf to your surface with a soft wide brush, patching up spots where the leaf didn't cover as you go. I either use a fresh sheet of leaf for patching, or very gently touch a little piece of brushed away leaf (called "skewings") to the spot I've missed.

In traditional gilding you would burnish your gilding down with an agate or hematite burnisher. However, with synthetic size, the size underneath is too soft for burnishing and you'll scuff your leaf. I find that if I place a piece of the gilding tissue paper over my gilding and rub over that briskly with my finger, it sticks well.

4 Brush Away Excess Leaf

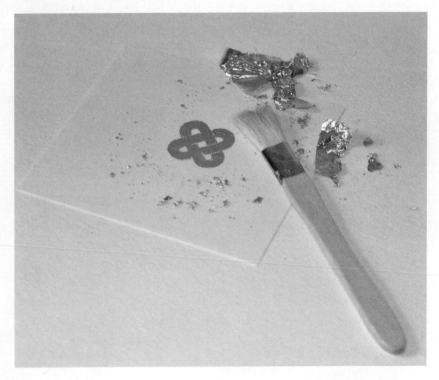

Using your wide soft brush, lightly scrub at the leaf to brush away all the excess leaf (skewings). You may need to work at some places, such as the insides of letters if you are leafing a word. Continue lightly scrubbing until all the skewings have come away and you are left with your finished design. Use a piece of cheesecloth or silk to polish it by lightly buffing in circles over the leaf.

If you find you've missed a spot or the leaf didn't stick very well to an area, just touch it up with more size and re-leaf it when it's dry. If the design's edges are a bit wobbly, use a craft knife (such as an X-Acto #1) and lightly scrape the leaf away on the edges to clean up the design. With re-leafing and scraping away, you can keep fixing up a project until it is perfect.

Color Basics

Color is one of the delights of any project! It can bring your design to life, adding mood and texture and vibrancy. Color theory is an extensive subject, but with the basics shown here you'll be able to choose colors for your projects and manipulate them.

The color wheels below will help you understand the basic terminology of color theory: hue, tint, shade, complementary, triad and split complementary colors.

If you're having trouble picking color combinations for a project, try simplifying your color scheme. Take one of your colors and change it to a tint or shade of one of your other colors. This will usually help to unify the look of your piece and can help make it look less busy or chaotic, which can be a problem if you have too many colors competing with each other.

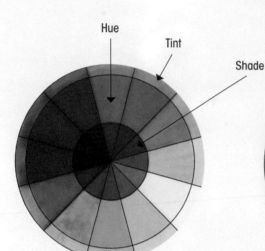

Hue · Tint · Shade

HUE, TINT AND SHADE

Hue, shown in the middle ring, is pure color. Tint, in the outer ring, is color with white added. Shade, in the center, is color with black added.

COMPLEMENTARY COLORS

Complementaries are the colors opposite each other on the color wheel, such as red and green. They make very strong and bold color pairings.

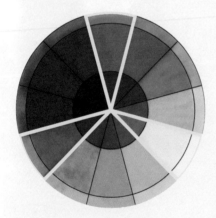

TRIAD COLORS

Three colors each one third away from each other on the color wheel. Another bold combination!

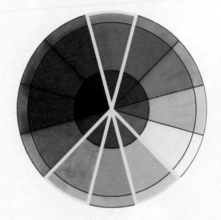

SPLIT COMPLEMENTARY COLORS

The two colors to either side of the complementary. They make a more subtle color combination.

Additional Color Combinations

Interesting color combinations can be created by mixing and matching around the color wheel. Here are some sample variations. Although each combination uses yellow, a very different effect is achieved with the other colors combined with it!

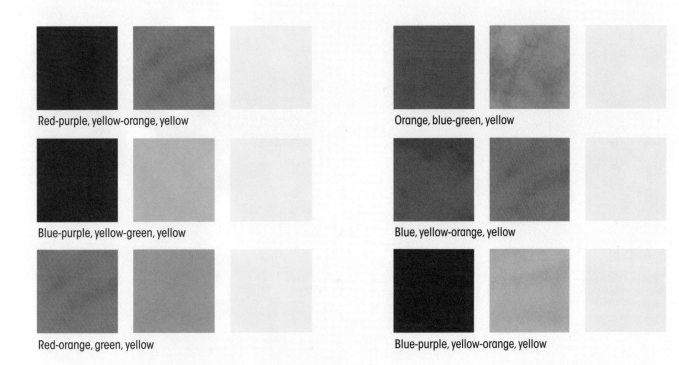

Red-purple, yellow-orange, yellow

Orange, blue-green, yellow

Blue-purple, yellow-green, yellow

Blue, yellow-orange, yellow

Red-orange, green, yellow

Blue-purple, yellow-orange, yellow

Water-Soluble Colored Pencils

Water-soluble colored pencils (also sometimes called "watercolor pencils") are used much like normal colored pencils, the only difference being that afterwards you can take a wet brush and liquify the color into rich wet watercolors!

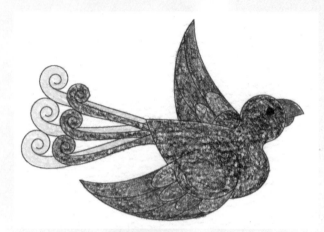

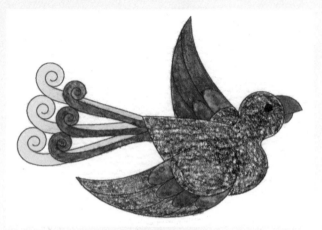

1 Start with a Water-Soluble Colored Pencil

Color in areas as heavily or lightly as you like. Colors can be blended easily by shading two colors into each other. When liquified they'll blend automatically.

2 Switch to a Wet Brush

Take a wet watercolor brush and lightly run the brush through your shaded color. Use a small brush to liquify small areas or detail portions of larger shaded areas, and a larger brush for large open areas of color. Adjacent wet areas will bleed into each other, so if you'd like to keep your colors distinct let an area dry thoroughly before painting the area next to it.

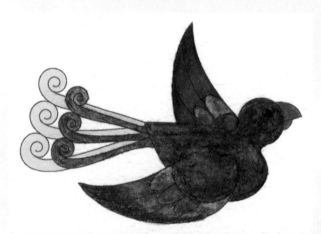

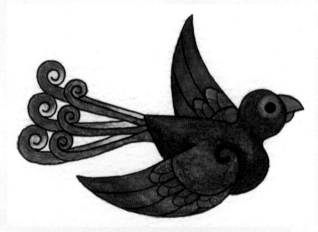

3 Add Shading with Colored Pencil

If you liquify too much, just shade color in again and liquify it again. Make sure to let the area thoroughly dry before coloring it again. Here I've shaded more purple into the tips of the wings, which when liquified blends back into the original colors.

4 Finish with Details

Let the liquified color dry. Once dry, you can add fine details on top with a fine ink pen or colored pencils.

Learn more about calligraphy at http://CariBuziak.artistsnetwork.com

Watercolors

Another way to add color to your calligraphy projects is by using watercolors. True watercolor painting is a broad topic in itself, but there are a few principles that you can use as a beginner to help you add some color to your project!

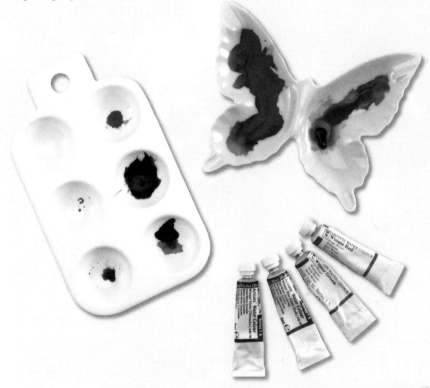

TUBE WATERCOLORS

Watercolor from tubes comes out as a thick paste. Squeeze out a small dab into a palette well, wet your paint brush and lift some color from your dab. Colors are mixed either right on your paper surface, in a separate well on your palette, or directly on the palette. The butterfly-shaped palette shown here is where colors are mixed for my own projects.

PAN WATERCOLORS

These are dried cakes of watercolor. Wet your paint brush and stroke the top of the cake to liquify the color. Colors again should be mixed in a separate palette well to keep your original colors clean.

Working Wet-into-Wet

In the wet-into-wet watercolor technique, the area to be painted is first wet with a clean paintbrush loaded with clear water. Once the water has soaked into the paper somewhat, the color is brushed onto the wet surface. This technique works well when you want to seamlessly blend colors together. However, it can be tricky to manage if the wet area is too large because once the drying areas begin to meet the new wet areas, you'll get ragged waves rather than smooth color changes. Try to blend quickly to keep the surface wet.

In small areas you can get some interesting effects if you add a touch of one color to another and watch them mix as they bleed together.

Working Dry

Paint the large body area by starting at one end and brushing towards the other.

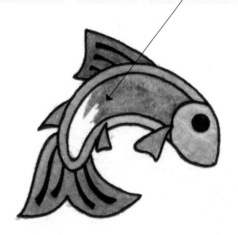

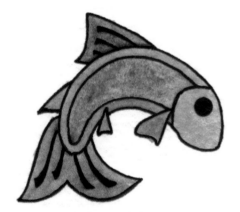

Working on dry paper is the simplest way to add color. Simply thin your paint as much as you like or mix whatever shade you like, and paint in an area as you would a coloring book. For large areas, start in one corner and make your way across the area so your leading edge always stays wet and you won't get streaking.

Learn more about calligraphy at http://CariBuziak.artistsnetwork.com

Tips on Using Watercolor

▶ Always let adjacent areas dry thoroughly before painting them. If you have just painted an area and it's still wet, painting the area adjacent to it will cause the colors to bleed into each other.

▶ If you've made a mistake and painted over an edge, take a small piece of paper towel and press firmly to the offending area. Some of the color will lift up immediately. Wait until the area is completely dry. Take a very clean, fine paintbrush and dip it in water. The brush should be damp, not wet. Dab excess water onto a paper towel if necessary. Lightly stroke the mistake area with the tip of the paintbrush. Small amounts of color should be removable. Although the area may never be perfectly white again, you can usually lighten it enough that once you've inked your outlines or added your other colors it won't be as noticeable.

▶ If you've painted an area and the color is streaky, you can sometimes lighten the streaky parts. Wait for the area to dry completely. Take a small barely damp paintbrush and lightly stroke over the streak. Wipe off the color from the paintbrush tip onto a piece of paper towel. The keys to this fix are to make sure the surface is perfectly dry, and make sure your brush tip is barely damp. Work slowly, lifting a tiny bit of color at a time from the heart of the streak until it's lightened enough to match the rest of the area.

▶ If you've mixed a special shade of color in a palette well and need to stop painting for the day, let the color dry out in the well. When you come back to your work, you can liquify the color again with some water on your brush. For color matching purposes it can be helpful to keep a smaller piece of your project paper on the side, and as you make new colors put a dab on your swatch paper with a note about what colors you used (as shown below). Then if you need to remix a shade again you can test it on your swatch paper and make sure it matches before painting it on your project. Always match dry color to dry color, not wet!

12 Calligraphy Projects Step by Step

Now it's time to have some fun with your new-found calligraphy skills! The projects in this chapter will show you just how many ways you can use calligraphy and ornamental lettering to enhance almost anything, from simple announcements and greeting cards, to fantasy artwork, logos, and more. We'll start with six projects for stationery and event announcements, then go on to six more challenging display items you can embellish with artwork!

Bookplates

Bookplates have a long history associated with illustration and calligraphy. As books in early history were precious and often expensive possessions, it was important to label a book to identify the owner. An owner would sometimes commission a bookplate design incorporating the family coat of arms or particular designs to show their areas of interest.

Bookplates are also called *ex libris* meaning "from the library of" and often the phrase Ex Libris is included in the bookplate design with a blank area for the owner's name, or with the name included in the design.

Creating your own personal bookplates to print out on label paper or inkjet sticker sheets is an easy and fun project for your new calligraphy skills!

1 Your bookplate can be any shape or dimension. However if you'll be printing them out on inkjet sticker paper you may want to choose a dimension that divides up the paper evenly to minimize waste. If you'll be using pre-cut office labels, see what sizes are available first and design your bookplate around that. My sample here is designed for a label that's 3½ x 5 inches (9cm x 13cm).

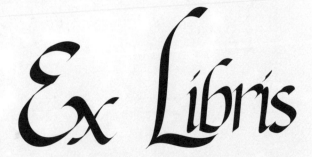

2 First decide what sort of feel you want your bookplate to have, as that will determine the calligraphy hand you want to use and the kind of embellishments you'll add. I've decided to make a very romantic design so have chosen italic letters with swash capitals. As bookplates typically have very over-the-top designs, I've made my swash capitals extra large in relation to the lowercase letters. I've written each word out on its own piece of paper so I can try some different ways of laying them out on the bookplate.

3 This layout fills the space above the "Libris" but makes the "Ex" feel a little disconnected.

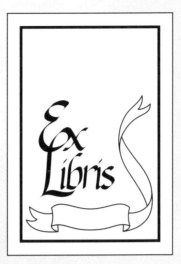

4 Here the "Libris" hangs off the "Ex" but both words still are very legible. I like how combining them adds an extra loop, like a flourish, to the letters. There's also a nice space created below it for adding a name within a nice banner (see page 64 for banner instructions).

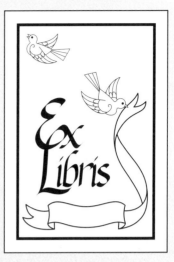

5 Having just a banner looks a little boring, so I'm going to add a little bird to hold up the top corner of my banner, and a little friend for him in the upper left corner.

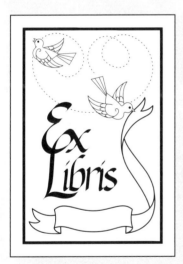

6 I still have space to fill, so I'll add a curling trail of dots from my birds, like a flight path.

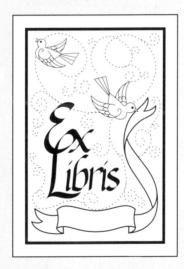

7 Using the same technique as creating vines, I'll add some extra curls to the flight path to fill my surrounding space even more.

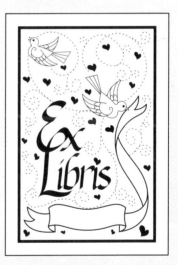

8 Finally I'll add some sweet little hearts of varying sizes, replacing the second dot over the "i" in "Libris" with a little heart.

How to Make a Banner

1 Start making a banner by drawing two joined parallel curved lines.

2 Add two forked ends on either side, slightly below the main banner.

3 Join the forked ends to the main banner with a small curve.

ADDING COLOR

With your artwork finished, you can now add some color to really make the design pop! Scan the finished design into your computer and print out on sticker sheets, or photocopy with a color photocopier and use a glue stick or double sided tape to apply to the interior of your books. Leave the name area on the banner blank so you can change the name at will and give your bookplates to friends!

4 To make a flourished banner tail, start with your main banner as before. Add two lines that curve from side to side, criss-crossing as they go.

5 Add a smooth curve to round out the "outside" of the flourish.

6 Erase part of the original curves to create a twisting sweeping tail.

Learn more about calligraphy at http://CariBuziak.artistsnetwork.com

Greeting Cards

Creating your own greeting cards is a great way to personalize your gift giving. Cards can be printed on plain cardstock or on many of the commercially made handmade papers that come in a variety of textures and colors.

To further personalize a card, try printing out the standard greeting or illustrations and then adding your own handmade touches of color or calligraphy to the printed card.

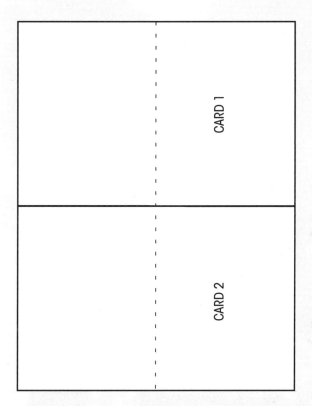

VERTICAL

Twas the night before Christmas, when all through the house

Not a creature was stirring, not even a mouse;

The stockings were hung by the chimney with care,

In hopes that St. Nicholas soon would be there;

The children were nestled all snug in their beds,

While visions of sugar-plums danced in their heads...

Merry Christmas

HORIZONTAL

STANDARD CARD SIZE

To create a standard card size that can be printed on a regular 8½ x 11-inch (22 x 28cm) sheet of paper, you'll need to mark off a design area of 8½ x 5½ inches (22 x 14cm). This will allow you to fit two cards per sheet when you print them out.

ORIENTATION

Next, decide how your card will be oriented. A horizontal card style will allow you a lot of room to write in large ornate letters, whereas an upright vertical card allows you room to write out full quotations of text.

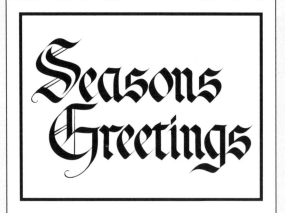

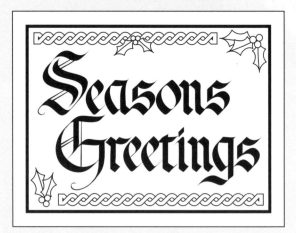

1 Most printers have a print area slightly smaller than a sheet of paper, so it's a good idea not to have your design run right to the edge or it'll be clipped. Keeping this in mind I've created an inner border to frame my design and enclose it. As this will be a holiday card, I've chosen Gothicized Italic for my lettering, which is formal yet highly decorative.

2 To dress up the card I've added some holly sprigs and Celtic knotwork to act as border decorations. This knot pattern is made exactly the same way as shown on pages 42-44, only instead of an equal number of dots horizontally and vertically, I've made it only a few dots high by many more long, to achieve the size needed to fit the space.

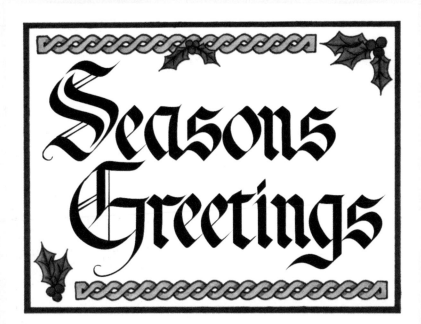

3 With the basic black and white card calligraphy and designs complete on my master copy, I scan the finished card into my computer so I can print multiple copies at will and color them each individually with a touch of watercolor. Be sure to scan at a high enough resolution that it will print nice and clean; usually 150 dpi (dots per inch) or 300 dpi is adequate. Save the scan as a high quality jpeg and place it in whatever type of graphic or design software you're comfortable with.

Alternatively, you can photocopy the black and white artwork onto nice paper, then create multiple copies.

If you have to send a lot of cards, you may want to consider coloring your card design first, then scanning it into your computer to print out multiple times. You can always add hand touches afterward, using a metallic pen to add some sparkle, or by calligraphing a name or message inside the card. But if you have only a dozen or two to send it's a nice touch to paint each one individually, making each card a work of art in its own right.

Learn more about calligraphy at http://CariBuziak.artistsnetwork.com

Bookmarks

Bookmarks are a fun and easy project and they're great to share with your friends and family. A bookmark can be any size that's appropriate to the kind of books you like to read, whether normal paperbacks or oversized hardcovers. Remember to laminate your finished bookmark to ensure that the inks or colors don't run or transfer to the book pages.

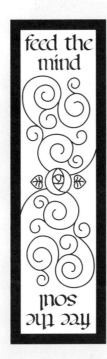 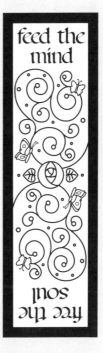 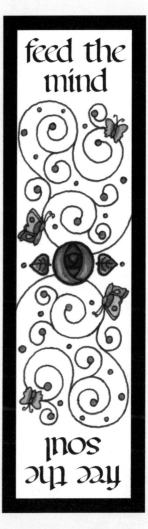

1 First, decide whether you plan on creating a hand-painted and calligraphed master bookmark and then reproducing it to share with friends, or a single standalone piece. If you plan on printing out copies of your bookmark, you'll need to leave a small border or print margin around the design so nothing is clipped when printed. If you're making just one, you can draw your design right up to the edge.

 For the text I wanted something light and free, so I've chosen Foundational for my calligraphy hand. To keep the informal feeling, I've used lowercase letters and no capitalization.

2 Balancing an art nouveau style rose in the center, I added some fine filigree scrollwork above and below.

3 To fill more space, I added some small dots around the design that can be colored or gilded, and a few cute little butterflies.

4 I then painted the finished piece in soft spring colors to marry the design with the subject.

Logos

A business logo can be made from a word or words, an image, or a combination of the two. The key to a well made logo is to keep it simple. If you use words, no one should have to struggle to decipher the name of your business. And if you use an image, it shouldn't be a hyper-realistic or overly complex design.

With a personal logo, you have a little more freedom of expression and can create something a little more complex, such as a monogram, for example. Monograms can be incredibly ornate combinations of two or more letters, wrapped together to create a detailed design, or the simple join of a few decorative letters to create a clean yet sophisticated image. Italic Swash Capitals are ideally suited for these kinds of designs.

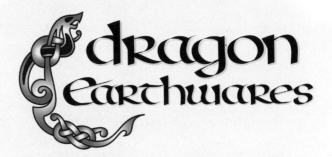

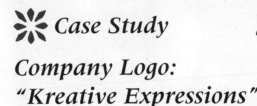

✻ Case Study

Company Logo: "Kreative Expressions"

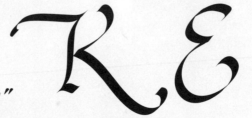

Let's try our hand at creating a simple logo for a company called "Kreative Expressions." Studying the capital letters "K" and "E," we can see that there are a number of curls that could be used in combination or overlapping each other.

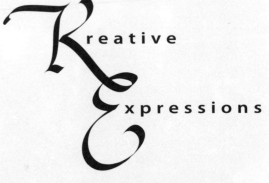

Although this is a nice combination, there is not sufficient room to write out the rest of the letters for the company name. This combination would be more suited to a personal monogram where you would not be writing out the full name.

This combination allows room for additional text, however the rhythm is not very pleasing and the letters just look "put together" as opposed to flowing smoothly from one to the other.

Here's a winning combination! The two letters flow easily into each other, and when paired with some simple text to finish the name, the completed design is both legible and elegant.

Business Cards and Letterhead

Most business cards are 2 x 3½ inches (5 x 9cm). A business card can take on many formats depending on whether you'll be printing them at home or taking them to a professional printer, and what your budget is.

If you're creating your cards yourself, you can purchase pre-perforated sheets of paper that load into your inkjet printer. After printing you simply tear the cards apart at the perforations. These cards are quick and easy, however the paper weight is usually thin and the perforated edges are noticeable on the finished cards.

For a better quality homemade card, purchase card-stock paper and cut the cards out by hand with a sharp knife and stainless steel ruler. You'll have a heavier card that will feel more professional, cleaner edges, and more options in the colors and types of cardstock paper to choose from. You'll have to experiment with papers to see what prints well from your printer, but the finished card will be well worth the extra bit of effort.

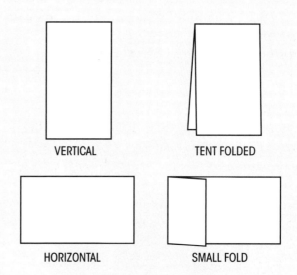

VERTICAL TENT FOLDED

HORIZONTAL SMALL FOLD

Business cards can be created in several different formats. Most are printed horizontally, but if there's a lot of information to convey, a folded card works well.

Decide what information you would like included on your card. At the minimum, it should have your name or company name, and a way to contact you, such as your phone number or email address. You can also include your title, website and mailing address if you choose. When in doubt, having a simplified layout and just the basic information needed will result in a more professional looking card.

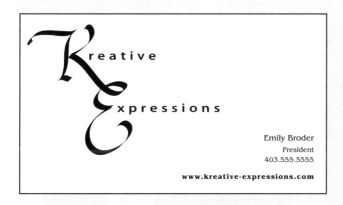

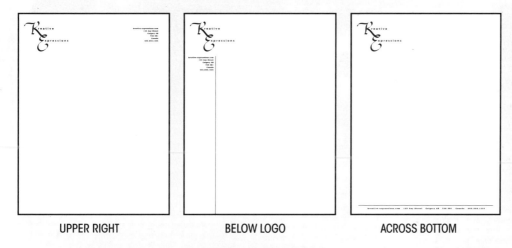

UPPER RIGHT BELOW LOGO ACROSS BOTTOM

Designing your own letterhead is quite straightforward. Your logo usually goes in the top lefthand corner, the interior is left blank for your communications, and then the rest of your company contact information is usually placed to the right of the logo, below it, or across the bottom.

Wedding Announcements

If you're planning your wedding or other special event several months in advance, it's a good idea to create a "Save the Date" postcard that can be sent to all your guests. While the complete details will be sent later in a proper invitation, a "Save the Date" card ensures your guests can at least reserve that date in their social calendar for attending your event. A "Save the Date" card usually matches your overall event theme in colors and style, and is usually a complementary design to the official invitation.

 Case Study

Event: Wedding
Clients: Andrew Coffin and Erin James
Date: September 27, 2011

For this example we'll use an ornate monogram style design with additional embellishments to dress it up. To really push the lettering over the top, I'm choosing Batarde Uppercase for its sweeping letterforms.

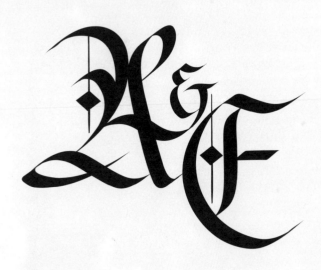

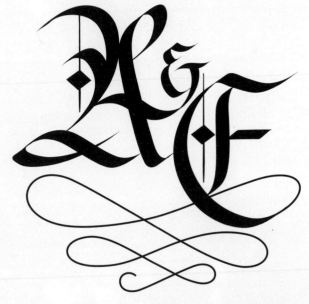

1 To begin, the letters should be combined in the most compact and pleasing manner. Here I've added a small ampersand in lowercase Batarde and joined the tip of the lower ampersand to the crossbar of the "A." Then I nested the "E" against them. As this is a personal monogram, legibility can be sacrificed to a small extent, however the letters should still be readable without too much difficulty.

2 A traditional flourish used in monograms and Copperplate style calligraphy is an undulating swash that flows from side to side, crossing itself and growing smaller as it tapers down. If we use the bottom tip of the "E" we have a natural starting point for this kind of swash. It also fills in the lefthand blank space under the "A."

Learn more about calligraphy at http://CariBuziak.artistsnetwork.com

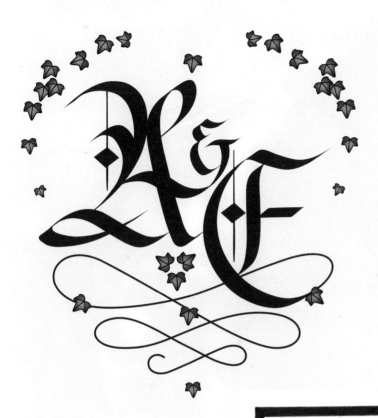

3 As the wedding will be in the fall, adding some ivy leaves in autumn colors of red and gold gives it a nice touch and provides areas of color. Arranged like this around the lettering, the leaves also create a vaguely heart-shaped design overall, which suits a wedding theme.

4 To complete the card, the names of those getting married are added (both first and last names), and the date to be saved. A short greeting and the words "Invitation to follow" are customary.

If you're printing the cards yourself, you can scan the final design into your computer, add the typed text for the date and greetings and print off multiple copies. If you're confident in your calligraphy skills and don't have many cards to do, try scanning in just the leaf and flourish details and then hand-calligraphing the monogram initials on each card individually for that handmade touch.

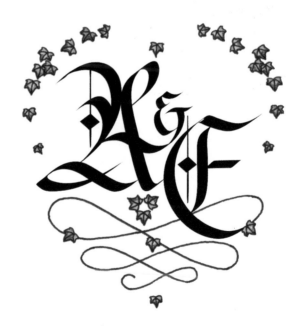

Save the Date
September 27, 2011

Please join us in celebration on our very special day.
Andrew Coffin & Erin James
Invitation to follow.

Invitations

After all the wedding or event details have been settled and the actual event date approaches, proper invitations need to be sent out. Invitations can be created from scratch; however if you sent out Save the Date cards, then usually the two will match in some way such as including a small detail from the Save the Date card, the color theme, or the overall layout.

As this is the actual invitation, we'll expand the original Save the Date postcard into a proper greeting card format to include all the additional details.

 Case Study

Event: Wedding
Clients: Andrew Coffin and Erin James
Date: September 27, 2011

Additional details needed for the official invitation include the ceremony and reception locations and attendance times, expected dress attire if applicable, and any special gift instructions.

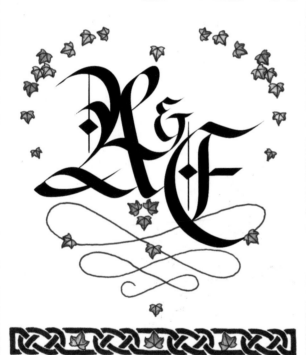

Please join us in celebration
on our very special day.

Andrew Coffin
&
Erin James

To be joined in matrimony on
September 27, 2011

Ceremony: 2:30pm
St Paul's United Church, 1142 Woodburn Drive

Reception: 6:00pm
Woodlands Community Hall, 1200 Woodburn Crescent

Our original monogram can now take center stage in the design. Enlarging it as much as possible still allows some nice room above and below to create a decorative Celtic knotwork border in heavy black to match the black in the monogram calligraphy. A few autumn leaves in the border tie the whole design together.

For the interior of the card, some of the fall leaves are used as little decorative elements to separate the text. Small scrolls added to the corner leaves create a nice finishing touch.

Place Cards and Thank-You's

Some additional items that you may want for a wedding would be place cards to lay out on the reception tables showing your seating arrangement for the guests, and thank-you cards to send after the wedding. Both are easily created using what you've already designed for the invitations and Save the Date cards, and are a nice touch to complete your entire wedding or event planning.

Place cards should be simple and easy to read with some small decorative elements added. If the names are hand-calligraphed they would be wonderful keepsakes for your guests to take home after the reception.

Thank-you cards are an essential part of good etiquette. Consider sending cards not only to the guests who brought you gifts, but also to thank people just for coming and sharing your special day.

Monograms

We've already looked at a basic monogram design, but developing a more ornate monogram can be a bit complicated once you start adding more details, embellishments, and letters. So let's look at some examples of how to break down different combinations.

Letters Create a Shape

In the style of monogram seen on these two pages, think of the letters as filling or creating an overall shape, rather than letting the letters define the design. This could be helpful in a project like a private commission for wedding stationery. Perhaps the client would like the overall shape to be a heart or to fill a shield shape like a coat of arms.

1 Decide on the Overall Shape

The first step is to decide on your shape. For this example let's use a shield shape and the letters T and F. You'll want to use a nice ornate alphabet (in this case I chose Gothicized Italic) so you have some flourishes to work with when filling your chosen shape. As you can see here, just writing our letters into the shape doesn't fill it very well, and does nothing to help define the edges.

2 Adjust the Letterforms

The gray letters show the original calligraphy as we learned it in the alphabet chapter; however, with a small amount of tweaking we can make the letters fit the shape much better. If you're having trouble seeing how the letters could be extended or rounded out to fill the area, try rough-sketching the letters in with a pencil first, and then calligraphing overtop once you like how it's filling in.

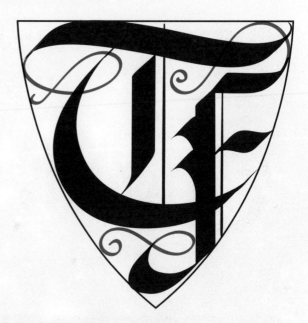

3 Add Flourishes

Adding some flourishes gives us a way to fill more spaces in the design. Springing off from a flip at the end of a normal stroke, continue the line with undulating curves back and forth and adding small curls at the ends.

Learn more about calligraphy at http://CariBuziak.artistsnetwork.com

4 Detail the Letters

On the original letter T, there are a pair of lines from the upright bar, but the angle of those lines doesn't allow me to incorporate them into the F to give the letters some symmetry. So I'm going to slant them a bit deeper, and add the matching pair to the F as an extra decorative touch. I'm also joining the two letters together with some hairline wisps from the back of the F to the T.

5 Finish with Decorative Touches

To finish the monogram, I gilded the shield border in gold and for some extra decoration, added a very light blue-and-white checkerboard pattern to the background. For more textural interest, some of blue squares are darker and some are lighter.

Center Stage Letter

This style is great for featuring a really ornate and fancy letter in the design. If the alphabet you've chosen to use has an especially beautiful letter that is also a letter that occurs in your monogram, you may want to choose this style.

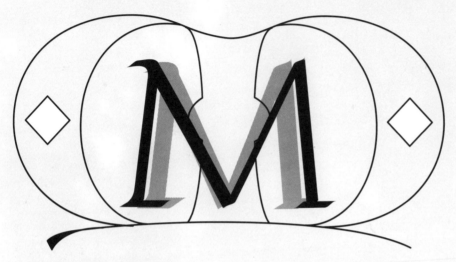

1 Choose Your Alphabets

For my ornate letter (the M shape with the curved sides), I'm going to use Lombardic Versals. The smaller M in the center of the ornate one will be just plain Roman. This gives me a nice ornate letter I can use for maximum embellishment, and a simpler letter to take backstage to my main letter. To fit the Roman M within my Versal M, I need to slightly modify the normal letter width and also make it more slender (the original Roman M is shown in gray above, and the modified M is in black).

2 Begin Ornamentation

The tops of the Roman letter M could use a bit more ornamentation, so instead of the usual Roman tops (see Step 1), I'll add some matching curls to either side. Adding a second outline within the Versal M is an easy way to increase the detail level as well.

Learn more about calligraphy at http://CariBuziak.artistsnetwork.com

3 Add Embellishments

Now that the main letters have been settled, it's time for some additional embellishments. First I'll add little half flowers to crown the two peaks on my inner M to create a bit of detail. The rounded shape of these half-flowers echoes the rounded shape in the middle of the stem of the Versal M.

4 Continue Embellishing

The flowers offer a good opportunity to weave a sweeping line back and forth across and through the letters.

5 Finish with Color

Finally, adding a full flower at the bottom point of the design ties the flourishes together. Note how the shape of that flower repeats the diamond shapes in the sides of the Versal M. For color, a dark royal blue on the Versal M, some lighter blue on the flowers, and gold on the edges gives this monogram a regal look.

Quotations

One of the projects you may wish to use your calligraphy skills for is to write out a poem, verse or quotation as its own piece of artwork. In this case, layout will be an important part of the look of the finished piece.

Text Selection

First you'll need to find a piece of text that captures your attention. This can be a verse from a sacred text, a poem, even a song lyric. Try your local bookstore or library for books filled with inspirational quotes, or visit garage sales or search the Internet. For the purposes of this project, select a text that's at least six words long.

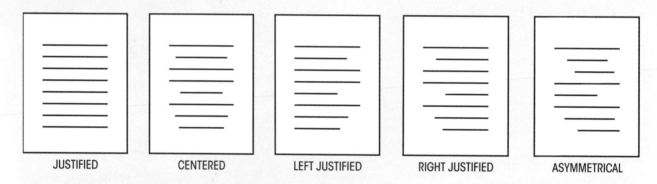

| JUSTIFIED | CENTERED | LEFT JUSTIFIED | RIGHT JUSTIFIED | ASYMMETRICAL |

TEXT ALIGNMENT

There are a few kinds of alignment styles you can choose for your text. To pick an appropriate style, think about the meaning behind your text. Is it carefree or lighthearted? Then the Asymmetrical layout might work well, whereas the Justified or Centered could be too rigid for such a light topic. Is it a formal text, such as a sacred or patriotic verse? Then a traditional layout such as Justified might be more appropriate.

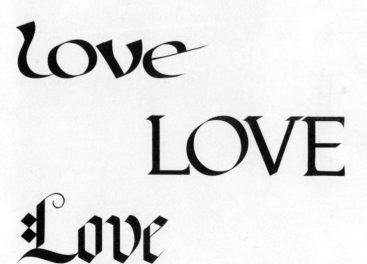

LETTER CHOICE

At this point you also need to think about the calligraphy hand you want to use. Again, look to your text to decide whether you want a very formal looking calligraphy hand or something looser. The lettering style you choose and the layout is what will give your text its expression, as can be seen with these three examples of the word "love."

Learn more about calligraphy at http://CariBuziak.artistsnetwork.com

Layout and Page Size

If you have a specific piece of paper you want to use for the project, then this will determine your page size and will also dictate the room you have available for the layout.

Take a look at your text. Are there any natural line breaks that you'll be using or could use? The text I chose for this project could be broken up in a few different ways.

Great spirits have always encountered violent opposition From mediocre minds.

Great spirits have always encountered
violent opposition From mediocre minds.

Great spirits have
always encountered
violent opposition From
mediocre minds.

This quotation by Albert Einstein can be broken into one line, two lines, or four lines.

Great spirits
have always encountered
violent opposition From
mediocre minds.

1 I find that I really like the first two words, "Great spirits," a lot. These are what capture me about this quotation. To emphasize them more, I'm going to use a four-line layout, and I'll drop the word "have" to the second line so that "Great spirits" is on its own line.

Great spirits
have always encountered
violent opposition From
mediocre minds.

2 Since I really want to emphasize "Great spirits," I'm going to choose a centered alignment. I'm using paper that I can cut to any size, so I'm going to let the text dictate the paper dimensions.

Be sure when figuring out your paper size that you leave enough space around your text to give it room to breathe. You don't want it crowded right up to the paper's edges, and you also want to leave enough room to have it matted and framed if you like how it turns out! Start with about 5 inches (13cm) around your text; you can always trim extra paper off after you're finished, but you can't add more on!

great spirits
have always encountered
violent opposition From
mediocre minds.

3 I want to keep the piece pretty informal, so I think that instead of capitalizing it I'll keep it all lower case. However, I'm going to enlarge the words "great spirits" to make them the center of attention.

great spirits have always encountered violent opposition from mediocre minds.

Great Spirits have always encountered violent opposition from mediocre minds.

Great Spirits have always encountered violent opposition from mediocre minds.

Great Spirits have always encountered violent opposition from mediocre minds.

4 I've chosen Batarde as my calligraphy hand because to me it's formal yet has a bit of flair. If the text were written out as shown here, it doesn't look too bad, but for such a declaration of self-expression and inspiration it needs to have more flex in its layout than this.

5 By enlarging the G and the S in "great spirits" a bit and adding some extra-long sweeps, I can give the words more visual interest. I let my pen play more on the flourish of the last "d" in the word "encountered." And in the word "mediocre" I use the swash tail on the "d" to dot the "i" following it. Most notably, I let loose a bit while writing the word "violent" to let the letters whip around a bit more to fit the word.

6 The text in this piece is very strong and bold, so black ink on white or cream matches the emotion with its stark contrast. However, by using two shades of ruby ink instead, it gives the piece a vibrancy that plain black can't achieve. The lighter shade of ruby ink makes the words "great spirits" pop even more.

7 A finished piece of work should always be matted and framed. A mat not only adds a colored border around the work, but it also acts as a spacer between the artwork and the glass. Condensation due to humidity changes can cause the inside of the glass to become moist, which can make the artwork buckle or, worse yet, make the ink run or smear! If you plan on shipping or handling the artwork frequently, you may want to consider using Plexiglas instead of real glass. It still has a nice appearance, however it's not as breakable and is lighter to carry or ship.

Certificates

A certificate is a common use for calligraphy today. Depending on how fancy you want to be, you could write out the entire certificate text, or just the recipient's name. A certificate looks great when written or printed on parchment colored paper.

Normally, certificates are issued en masse to a graduating class of participants or students, so you will only be calligraphing their names and the award date.

Like the quotation project, it's very helpful to plan as much of your layout as possible before you actually begin the calligraphy, unless the client has provided you with a template or copies of the actual certificate to use.

 Case Study

Title: Certificate of Completion
Date Awarded: January 30, 2011
Instructor: (leave placeholder for instructor's signature)
Recipient: James Doogan

Text: This is to certify that "___" has successfully completed all requirements for the Master Course, as offered by the National Calligraphers Association. Certificate awarded this "___" day of "___."

Let's assume the layout hasn't been predetermined by the client, and you need to begin from scratch. Typically certificates use a centered alignment; most certificates also have a decorative border and a seal, logo or some type of official decoration that you should leave room for. You will also have to leave room in the text for the instructor's signature, sometimes a Dean or Principal signature, the student's name, and the date.

Lettering Your Certificate

The certificate title could be left as typed text on your master, or you could calligraph the title, scan it into your computer at minimum 150 dpi (preferably 300 dpi), and drop it into your layout so it would be on every printed certificate. A nice strong Gothic hand is a great traditional choice for the title.

A simple border created using black squares is an easy way to decorate and frame a certificate. Many computer programs also have a clip art collection of borders and frames that could be used to decorate your master certificate layout.

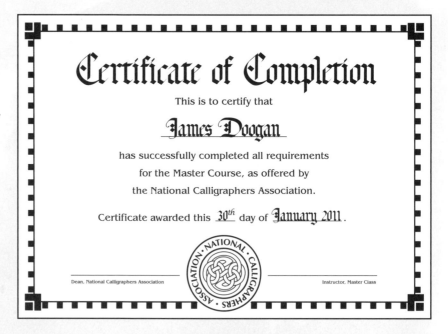

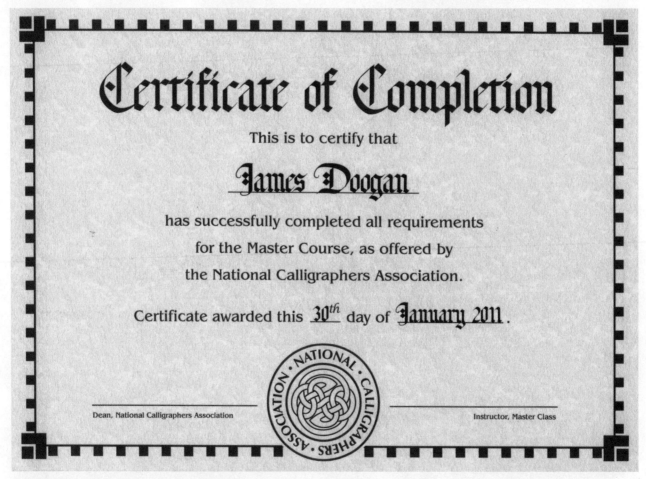

With your master copy completed, you can print out as many certificates as required. The participant's name and the date are always added by hand, never typed and printed. Once the calligraphy for the names and dates are completed, the certificates can be returned to the client to add the signatures and hand out to their students.

Learn more about calligraphy at http://CariBuziak.artistsnetwork.com

Lettering with Celtic Decoration

Celtic knotwork is a fabulous way to dress up a card or announcement, and so far we've covered how to create stand-alone knots. In this project we'll use a birth announcement to practice using Celtic knots to fill our actual letters. Using the knots this way creates a very gala effect!

Matthew ⟶ Matthew

Tim ⟶ Tim

William ⟶ William

Uncials are the calligraphy used in the old Celtic manuscripts, so it makes a natural choice for use with Celtic knots. In the old manuscripts, they played a lot with letter size and arrangement, nesting letters into each other and combining them to save space. This can be a very fun effect to play with! Double letters, like the two T's in the name Matthew, are good to nest or combine, as are specific letter pairings like the "T" and "i" in the name Tim, for example.

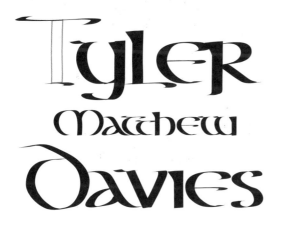

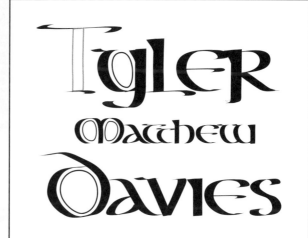

1 This is my basic layout for the birth announcement card. After having made some adjustments to the two T's in the name Matthew, I've enlarged the first letters of the names so there's plenty of room for adding decorations within them. I also created a modified T for Tyler so I can vary my decorative style a bit. As such, I've hand drawn the body of the T in pencil so I can work with it more later.

2 Letters with nice fat bowls are great for decorating inside. With Celtic decorations, you should leave a small space or gap between the inside of the letter and the decorative part. This helps keep the letter legible as well as giving it a traditional Celtic look. I've added an "egg" in the "y" of Tyler, two eggs in the "M" and a large egg in the "d," all of which I'll decorate later.

Decorating the Lettering

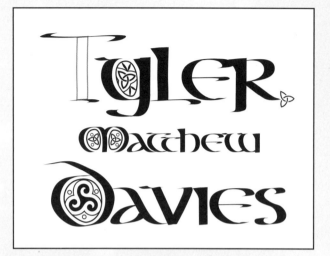

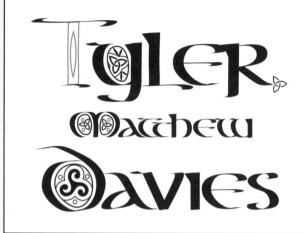

3 I work a tiny Celtic decoration into each of the "eggs" within the bowls of the letters, and add a little trinity knot to the tip of the R. (See the facing page for instructions on making a trinity knot.)

4 To make the "T" of Tyler easier to work with, I split the main stem into two by opening a space down the center.

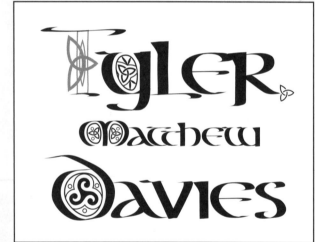

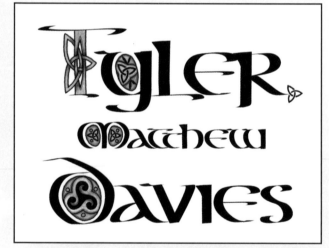

5 I then add a trinity knot through the split in the stem of the "T." The knot is angled so I need to draw it somewhat foreshortened.

6 The trinity knot weaves through the opening in the stem of the "T," with some parts in front of the stem and others behind for a dimensional look. Painting with shades of blue and golden-yellow give this birth announcement card a nice finished look!

Learn more about calligraphy at http://CariBuziak.artistsnetwork.com

Making a Trinity Knot

1 Sketch a dividing line, putting a dot to the lower left and lower right, and at the top.

2 Draw a fat arc starting at the top dot, arcing to the right of the divider, and over to the lefthand dot.

3 Draw another arc from the top dot, down to the left of the divider, and over to the righthand dot.

 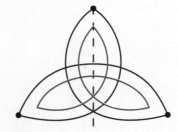 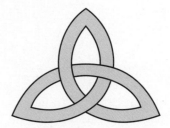

4 Join the left and right dots together with an arc that bows upward in the middle. This completes the basic outside shape of the trinity knot.

5 Now draw a second trinity knot line on the inside of your first line. Keep the width even throughout.

6 Weave your overs and unders to complete. Study the knot above and see which intersecting lines from Step 5 need to be erased. Fill in wth a color of your choice.

Illustrated Poems

Creating a complex piece of artwork incorporating calligraphy, illustration and painting techniques can be daunting! However, each of these steps has been tackled in previous projects—the key is to plan carefully, and take your time. With everything you learned so far you'll see it's easy to create your own detailed work of art!

> I would that we were, my beloved,
> white birds on the foam of the sea!
> We tire of the flame of the meteor,
> before it can fade and flee;
> And the flame of the blue star of twilight,
> hung low on the rim of the sky,
> Has awakened in our hearts, my beloved,
> a sadness that may not die.

As always, decide on your text and what you want to say. I've chosen this piece by W.B. Yeats because it has a sad yet romantic flavor, and has very strong imagery for me to use when I create the illustrations.

> I would that we were, my beloved,
> white birds on the foam of the sea!
> We tire of the flame of the meteor,
> before it can fade and flee;
> And the flame of the blue star of twilight,
> hung low on the rim of the sky,
> Has awakened in our hearts, my beloved,
> a sadness that may not die.

1 I like how the poem speaks of the birds on the sea, and a meteor flame. I think this would create an interesting opposition in the illustrations, especially if I worked the designs in mirror image to each other.

 Because my artwork will be reflected left to right, I want my text to anchor the designs by being very symmetrical in the center, so I'm choosing a centered alignment for the poem. Next I'll create a few borders to begin a frame that surrounds the entire piece.

2 A Celtic border inside the frame is easily done by creating a large dot grid when beginning your knotwork, and blanking out the center to make a hole (see page 89 for instructions on making a knotwork frame).

3 Flames and waves and smoke and clouds all have a similar loose and free-flowing feel to them. I'm going to use these shapes to create a mirror image of swirls, half of which will be waves, and the other half flames from my meteor.

> I would that we were, my beloved,
> white birds on the foam of the sea!
> We tire of the flame of the meteor,
> before it can fade and flee;
> And the flame of the blue star of twilight,
> hung low on the rim of the sky,
> Has awakened in our hearts, my beloved,
> a sadness that may not die.

Learn more about calligraphy at http://CariBuziak.artistsnetwork.com

4 Here I've added color to my sketches so I can decide on my color scheme before I start painting the final piece. With some sample colors in place, you can see how the two halves will look. I add some dotted vine curls to either side to fill space and some little dots of flame and water spray.

5 Lastly I add sketches of two white birds on the water side, and two meteors on the flame side.

If you're ever not sure of your color scheme, try printing or photocopying your sketch and testing colors with colored pencils before committing to your final piece.

6 Now that I know what colors I'll be using to paint the illustration, I can move on to the final painting. I'm going to use a metallic gold ink for the knotwork in my border. Gilding would be quite tedious for so many small areas!

7 Painting the flames and waves is easy! By using transparent watercolors I simply paint one layer of green on the wave side, and one layer of yellow on the flame side. Don't worry if the paint is streaky—go with it! Use it to add extra swirls in your waves and flames. Let dry.

8 Now I paint the remaining blue waves and the orange flames, which will sometimes pass over the previous yellow and green areas. The transparent colors will mix into additional shades automatically as you paint, no special mixing required!

i would that we were, my beloved,
white birds on the foam of the sea!
we tire of the flame of the meteor,
before it can fade and flee;
and the flame of the blue star of twilight,
hung low on the rim of the sky,
has awakened in our hearts, my beloved,
a sadness that may not die.

9 I've left the border painting until now because if I had painted it before my flames and waves, if the brush accidentally touched this dark blue border it would have bled the dark color into my light flames and waves. Doing it at this stage when the others are dry keeps the colors nice and clean.

Finally I paint my birds and meteors and add some last finishing touches.

Using the line breaks and layout shown in my mockup, I can add my calligraphy to finish the piece.

Learn more about calligraphy at http://CariBuziak.artistsnetwork.com

Making a Celtic Knotwork Frame

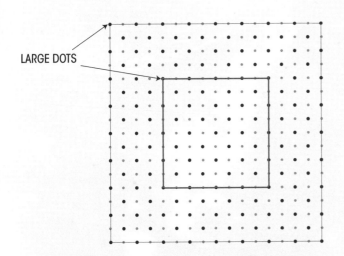

LARGE DOTS

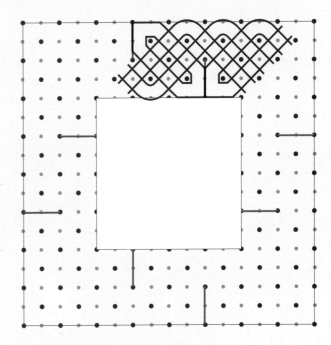

1 To make a Celtic knotwork frame, first create a very large dot grid. Draw an outer border, as well as an inner border. Make sure these borders begin and end on large dots!

2 Working just within the border area, add "walls" and proceed as you normally would with the tic-tac-toe pieces and the elbows and corners. See pages 42-43 if you need to review the steps for making Celtic knotwork.

3 Now weave your overs and unders, studying the frame at left to see where you need to erase your intersecting lines.

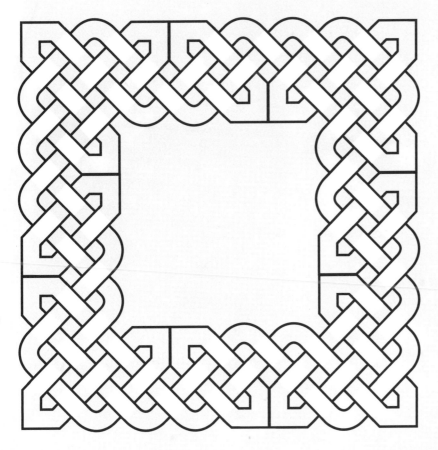

Lettering with Dragon Art

For our final project we'll include a fantasy piece of illustration with a poem. Fantasy images are great to play with if you are new to drawing because no one can tell you what it's supposed to look like—it doesn't exist! For this piece I've chosen a dragon design to illustrate part of a poem by W. B. Yeats.

Great Powers of Falling wave and wind and windy fire,
With your harmonious choir
Encircle her I love and sing her into peace,
That my old care may cease;
Unfold your flaming wings and cover out of sight
The nets of day and night.

The imagery of this text is wild and elemental, so instead of a rigid layout with my illustration I'm going to let the text flow naturally around the artwork. In order to know what kind of space I have, I need to complete the dragon first before I add the text.

1 A serpent style dragon isn't hard to draw! Create flowing curves to make his body, tapering thinly at the tail and making a bulge in the middle for a belly. This dragon is loosely based on the shape of the letter S.

2 I fill in the space behind him with a wing attached to his shoulder. For wing ideas, look at bird or bat wings and make it as fanciful as you like! To make my dragon a little more interesting, I add a heart-shaped flare on the tip of his tail, and draw an outline around his fat belly area so I can color it differently than his main body color.

3 The belly or main body could be covered in scales of different sizes; however for this design I want to keep it a little simpler. Instead I'll add a few scoops on his belly and neck to color and imply his other scales. Then I add a fringe to his head for fun.

Learn more about calligraphy at http://CariBuziak.artistsnetwork.com

4 Lastly I add a trinity knot to his wing (an elon-
gated, stylized one!), and some extra touches to
his fringe and wing for decoration.

5 With the dragon figured out, I can
now work out how my text will fill the
space around him.

Great Powers of Falling wave and

wind and windy fire,

With your harmonious choir

Encircle her I love and sing her into peace,

That my old care may cease;

Unfold your Flaming wings

and cover out of sight

The nets of day and night.

great powers of falling wave and

wind and windy fire.

with your harmonious choir

encircle her I love and sing her into peace,

that my old care may cease;

unfold your flaming wings

and cover out of sight

the nets of day and night.

6 Watercolors give nice, rich, fiery shades on the dragon, painted in hues of reds and gold with a little
black to give him some drama. A calligraphy hand in Carolingian or Uncial would be good choices for
this piece. I chose Carolingian to give it a bit of a rustic feel but with a little more sweep to it than a
perfectly rounded Uncial would give.

Creating Your Own Computer Fonts

Now that you've worked on a number of calligraphy hands, wouldn't it be nice to be able to use some of your letters at the press of a key? You could, if you made your calligraphic letters into a computer font! Creating a font isn't as complex as it sounds, and with minimal expense you too can create your own computer calligraphy font for personal use or for sharing with your friends.

Font vs. Hand Calligraphy

Hand-written calligraphy is an art, each letter beautifully expressed and drawn by hand. A computer font is a collection of static letters that can by typed at will with a press of a key. But how do you create a font from calligraphy? First let's cover some definitions.

Some Terms to Know

Glyph
Any graphic within a font. This can be a letter, number, or a symbol such as a dollar sign or punctuation.

Encoding
Each glyph is encoded with instructions so that the computer knows to type an "A" when you press the "A" key on your keyboard. At one time Macs and PCs used different encoding instructions or standards; however, the new Unicode Standard is a universal standard that both Macs and PCs will recognize and understand and it's what we'll be using in our discussions here.

Generating a Font
While you're building your font, you'll work directly in the font making software. When you're ready to install it in your computer to use it, you will need to "generate" the actual installation copy.

Metrics
Spacing rules that you want your font letters to follow so that they're spaced correctly when you type words and paragraphs.

Font Family
A font family includes a number of related font faces, such as a bold version, condensed, italic, light, etc.

Note

Every effort has been made to make these instructions as accurate as possible; however, computer software changes all the time with revisions and updates. Download the latest copy of the free manual for TypeTool to keep up-to-date on the latest changes and recommendations for the program.

Computer Windows

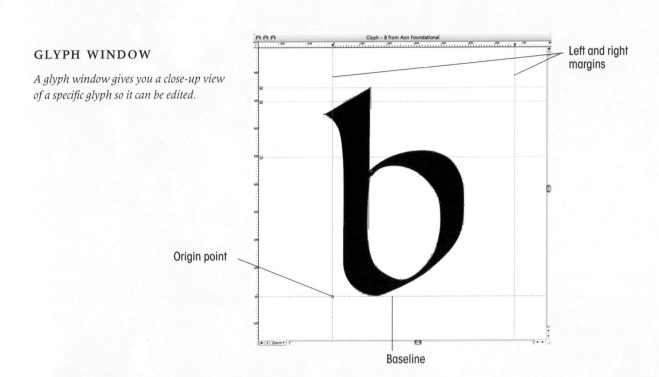

FONT WINDOW

This window gives you an over-view showing all the glyphs in your font.

GLYPH WINDOW

A glyph window gives you a close-up view of a specific glyph so it can be edited.

Left and right margins

Origin point

Baseline

METRICS WINDOW

A metrics window allows you to set and edit the distances between the glyphs (kerning, kerning pairs and tracking).

Computer Hardware

To create a font you'll need a computer (Mac or PC), and font creation software. If you plan on hand calligraphing your letters to use as a basis for your font, then you'll need a scanner to scan them into the computer. If you will be creating them digitally, then you can do that within the font software or in a vector or bitmap program.

Font Software

Font software is pretty unique and specific, as you can imagine. The industry leader, FontLab (fontlab.com), has several options for everyone from professional font-makers to home hobbyists.

The font software we're going to use for this chapter is their entry level product called "TypeTool." TypeTool is available for both Macs and PCs and is quite inexpensive, and can also be downloaded as a demo version that you can try before you buy it. TypeTool lets you create a font and export it so you can install it to use in a normal computer program like Word.

Hand-written Calligraphy

If you want to calligraph your letters by hand, you'll need a scanner so that after writing out your letters, you can scan them into the computer and get them into TypeTool. It can be helpful to write out several copies of each letter so when scanning you have a few to choose from, and you can select the nicest of each to include in your font.

Scan your letters at about 150 dpi, and save each letter in its own file (e.g., one file for letter A, one file for letter B, and so on). Save the letter files as JPEG or TIF formats so that when you start building your font, they're all ready to go.

Digital Letters

You can also create your letters in a vector-based graphic design program (such as Freehand, Adobe Illustrator™, Corel) and save the file in EPS format. These can be expensive programs to buy, but do offer some nice digital calligraphic brush shapes to use and customize for your lettering. TypeTool also has a calligraphy brush tool that can be used to draw letters right in the software. You can also use the calligraphic brushes in bitmap graphics software (for example, Adobe Photoshop™) and then save these as TIFs or JPEGs for use as background images to trace over in TypeTool. Again, save each letter in its own file (a file for A, a file for B, and so on), and make sure to work at a resolution of at least 150 dpi.

Learn more about calligraphy at http://CariBuziak.artistsnetwork.com

Making a Font

First, download your copy of TypeTool and install it in your computer. Launch the program, and under the "File" header along the top, select "New" (File > New). This will open a new template font document for you to begin creating your font in. Now under the "File" header, select "Font Info" (File > Font Info), and here you'll name your font. This area has other settings that can be set; however, to keep things simple for your first font, you're just going to name it and leave the rest as the default setting.

I'll be basing my font here on my Foundational hand, so I'm going to call it "Aon Foundational" after my company name, Aon. This is the name that the font will be called when you install it in your final software like Word, and are looking for it in your font list, so it helps to keep the name short and memorable!

The information boxes under the name are used by your final software (like Word, for example) to list the options for your font, such as bold, condensed, extended, light, italic, and so on. If you click the pull-downs you'll see the options available for each. My Foundational font is not thick or thin or italic, so I'm just going to select "normal" and "regular" for these settings.

Now that the basics are set, save your file by going to "File > Save." The name you save it under here is what your working font will be called, so you can call it anything you like.

Glyph Window

In the font window you'll see a bunch of boxes showing letters and symbols for your font. These are just place holders, which you'll be replacing with your own letters and symbols. Double-click the lower case "b" to open the glyph window for the lower case "b."

In the glyph window you'll see a sample letter "b" and some alignment lines used to place your letter properly. The horizontal lines are designated as "A" (ascender), "C" (capitals), "X" (x-height), and "D" (descender). The other guidelines are as follows:

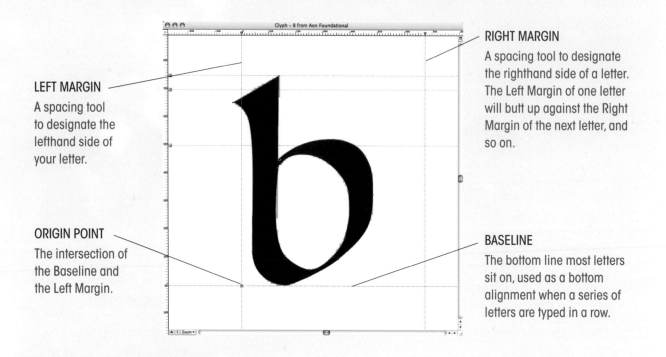

LEFT MARGIN
A spacing tool to designate the lefthand side of your letter.

RIGHT MARGIN
A spacing tool to designate the righthand side of a letter. The Left Margin of one letter will butt up against the Right Margin of the next letter, and so on.

ORIGIN POINT
The intersection of the Baseline and the Left Margin.

BASELINE
The bottom line most letters sit on, used as a bottom alignment when a series of letters are typed in a row.

Making Letters Using Vector EPS

If you've made a vector letter in a program like Freehand or Adobe Illustrator, select the letter in your vector program, "Copy," then open the appropriate glyph window in TypeTool and "Paste" the letter into place. These letters are now ready to move on to the next step.

Making Letters Using a Bitmap Program

If you've scanned your calligraphy letters in or have made them in a bitmap program like Adobe Photoshop, you will first need to trace the letters so you can edit and use them. In TypeTool, open the glyph window for the appropriate letter. Under "File," select "Import" and then "Background" (File > Import > Background). Navigate to your saved letter and import it into the glyph window. To move or scale your background letter, go to "Tools > Background > Move&Scale" and use the control box handles to make sure your letter sits on the baseline and the x-height of the letter matches the x-height horizontal line of the glyph window.

Learn more about calligraphy at http://CariBuziak.artistsnetwork.com

Using the Pencil Tool

Now you'll need to trace this background image to create an editable version you can work with. Under "View > Toolbars" select "Paint" to open the Paint toolbar. Select the "Pencil" tool.

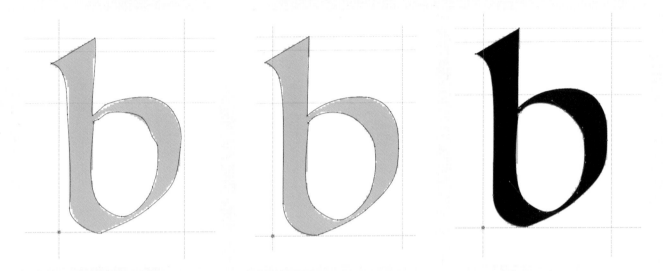

1 First, use the Pencil to draw the rough outline of your letter.

2 Using the handles of each node point on your letter, reposition and smooth them out so they follow the background shape closely.

3 Once completed your letter will appear black to indicate the shapes are closed. If your letter still appears as outlines, then the outside line of your "b" and the inner hole in the "b" have not been made as closed loops. A letter must be made of closed loops to work properly.

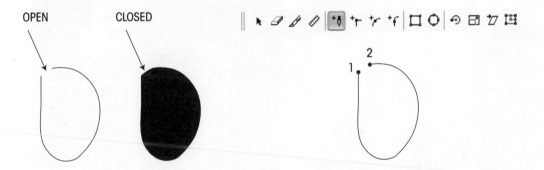

OPEN CLOSED

4 If you have to close your shapes, just slightly move each point and node until you find the two loose ends. Position them very close together (zoom in so you can see), and then use the Pen tool to click first one endpoint, then the second endpoint, and it will join the two ends together and close the shape, turning it solid black. I find it helpful to first close the inner hole shape before the outer outline, so you can see what you're doing before the letter turns black.

Editing Letters

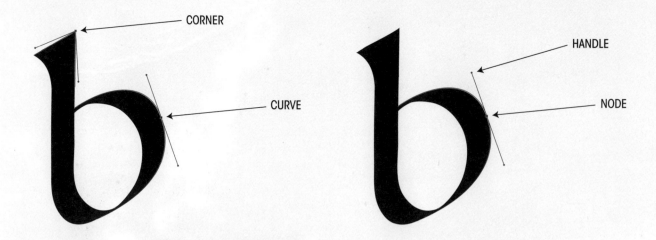

CORNER

CURVE

HANDLE

NODE

Each letter is created with a series of lines controlled by nodes. A node may be along a curve, or a corner. If you click on a node, you'll see two lines springing out from either side of it (shown in red above), each ending with a little handle. By clicking on a handle and dragging it around with your mouse, you can change the shape of the lines on either side of your node. After positioning your node on the edge of your background image, use the handles to change the lines on either side of your node so they follow your background image.

To delete a node, simply right-click the node and select "Delete Node" from the pull-down menu.

Cancel

Make Node First
Convert PS/TT
Delete Node
Retract BCPs

Reverse Contour
Contour

Break Contour
Make Corner
Connection

Properties...

Learn more about calligraphy at http://CariBuziak.artistsnetwork.com

Using the Brush Tool

With your Paint toolbar, select the "Brush" tool.

The Brush tool can be customized to resemble the cal-ligraphy pen tip you would have used to draw this letter by hand. The "Width" will depend on the particular letter you're recreating, so set a test value and increase it or decrease it once you see how thick it is writing. The "Angle" should be set according to your calligraphy pen angle. For example, Foundational has a pen angle of 30 degrees. Subtracting 30 degrees from a 90-degree angle, you get 60 degrees. So set the "Angle" here to 60 degrees. Set the rest of the values as shown in the example at left.

1 With your Brush tool values set, write over the background image to create each stroke of your letter in the same order and direction as you would with a calligraphy pen.

2 Once you've finished all your strokes, in your top menu choose "Edit > Select All" to select all your strokes at once. You'll see that parts of your strokes will overlap other parts.

3 Once In your top menu, select "Contour > Transform > Merge Contours" to unite your separate shapes into a single letter. Make any adjustments to your nodes to make the letter nice and smooth so it matches your background template.

Continue to trace each letter to fill at least all the upper case and lower case letters for your font.

Setting Margins

Each letter should be sized and positioned so it sits between the baseline and x-height, with the ascenders and descenders matching just as they would if you were writing them by hand. The Left and Right Margin lines should be close to each side of the letter. To move the Margins, click and drag the line (you'll see a double-headed arrow appear) to either side. Usually the Margins don't sit so close to a letter that they touch the side edges, but they are fairly close. A little breathing room to either side is good so the letters don't run together when typed. Too much room and they will look disjointed when typed. You can tweak this spacing when you work on the Font Metrics, especially in regard to some special instances of particular letter pairs.

Font Metrics

In this section we'll make any adjustments to the spacing between our letters, so when words are typed no letter pairs are jammed too close, or gapped too far apart.

1 In your top menu, select "Window > New Metrics Window." In this window select the Preview view (the little hand symbol on the right side of the window) so you can adjust your kerning and preview what it'll look like as you make your changes. By placing your cursor in the bottom field of the box, you can type letters and see how they'll appear as a font.

2 Type your own combinations of letters, or click the little black arrow to select any premade letter combinations to test the kerning.

Learn more about calligraphy at http://CariBuziak.artistsnetwork.com

Adjusting Font Metrics

You can adjust the metrics of a letter by manually opening its Glyph window and moving the Left and Right Margin lines. However sometimes you need to see the letter in context with other letters to decide where you want to position these lines. For example, with the letter "s," I've typed a few sample words with it and I see that the Right Margin is perhaps a little too far right because in each instance the letter following the "s" is a touch too close. So this tells me that the problem with my "s" is a global problem, not a unique problem with a particular letter paired with my "s."

1 To correct this, click on the Metrics view (the little "|M|" symbol on the left side of the Metrics window), and click on the letter "s." You'll see some metric information appear under the letter, and also the Left and Right Margin lines.

2 By dragging the Margins to the left or right, you can see in a flash how it affects your words, and tweak it just right.

Adjusting Kerning

1 Kerning addresses problems with specific letter pairs. In this example I've typed some letter combinations using the letter "a." All the letter pairs look pretty good, except for the "ag" pair. If I simply adjust the metrics of my letter "a," then it would affect the spacing of all of these pairs, rather than just the "ag" pair I want to fix.

2 So instead, this time I click on the Kerning view (the "A/v" symbol on the left side of the Metrics window). By positioning the cursor between the two problem letters I can drag the line to the left and close the gap. Now, whenever this particular pair of letters is typed, it will use this special spacing adjustment so they read properly.

 Continue to go through all your letters and use the pre-made letter combinations to tweak the metrics of your letters. It's not uncommon to make further changes down the road after using your finished font for a while, so don't worry if you haven't got it perfect the first time!

Learn more about calligraphy at http://CariBuziak.artistsnetwork.com

Font Creation

So far you've been saving just a working, editable copy of your font. To make an actual font that can be installed into your computer and used in programs like Word, you need to take your working font and generate the actual usable font.

In the old days, fonts used to be created differently for Mac and PC computers. Today the new standard is "OpenType," which can be installed on either, so this is what you'll use to generate your font. Before you generate your font there are some final details that should be checked to make sure it generates properly. To do that, complete the following steps using the "Font Info" window:

1 Under Names and Copyright, be sure you've filled in the font name and all the descriptive fields like Bold or Italic, etc., and any copyright or designer information.

2 Under Metrics and Dimensions, click on "TrueType-specific metrics." Select the button "Set custom values" and then click both the "Recalculate" buttons.

3 Under Metrics and Dimensions, click on "Key dimensions." Check the checkbox that says "Copy values to TrueType metrics."

4 Under Encoding and Unicode (highlighted in green above), click the green diamond button.

Last Steps

Finally, you'll need to make sure all the curves are correct for your letters. With your Font window open, select all your letters by going to the top menu and choosing "Edit > Select All." Then go to "Contour > Correct Connections" and choose "yes" when prompted. Because you're making an OpenType PostScript font (OpenType PS) you also need to make sure your curves are correct for this format, so follow these three steps:

1. Under the top main menu, choose "Contour > Convert > Curves to PostScript" (this selection may be grayed out if they are already in PostScript format).
2. Under the top main menu, choose "Contour > Paths > Set PS Direction," and choose "yes" when prompted.
3. Under the top main menu, choose "Tools > Hints & Guides > Autohinting," and choose "yes."

Finally your font is ready to generate! The generated files are what can be installed in your computer just like any other font you may buy on a CD or download off of the Internet. To generate your font, under the top menu choose "FIle > Generate Font." For the Format, choose "OpenType PS" and then "Save."

Font Installation

How you install your font will depend on your computer and current operating system; however it will be the same as installing any other font. If you have any troubles or need more information, check your computer's "Help" menu for the most up-to-date information on how to install a font on your system. Once it's installed, you will be able to select your font from the font list in computer programs such as Word.

Learn more about calligraphy at http://CariBuziak.artistsnetwork.com

Computer Software Updates

Since software is constantly being updated and revised, use this handy sheet to keep track of any changes to your computer's software that may affect the instructions in this chapter. Write down what the change is, what page in the book is affected, and the date.

UPDATE / REVISION / CHANGE	PAGE(S) AFFECTED	DATE

Pre-printed Celtic Knotwork Grid Paper

Here are some handy pre-printed grids for you to practice drawing Celtic
Knotwork. Make photocopies of the grid so you have several sheets to
practice on, and review the step-by-step instructions on pages 42-44.

Learn more about calligraphy at http://CariBuziak.artistsnetwork.com

Pre-ruled Calligraphy Practice Pages

The following practice pages have been pre-ruled for you for each of the calligraphy hands we've covered in this book. To practice, make several photocopies of each page to work your practice letters on so you always have a fresh master copy to make new copies from when you run out.

Each practice session, or when you're learning a new calligraphy hand, should begin with some warm-up exercises. Using the recommended nib width, work through the sample strokes we covered in Chapter 2 to loosen up, taking care to practice the movement of the pen and maintaining the angle needed for that lettering type.

When you feel you're ready, begin practicing the actual letters. Make each letter several times to prac-tice its shape and stroke construction before moving on to the next one. Before long you'll have covered the entire alphabet and it won't take long before you start seeing some nice letters in each practice set. The more you practice, the more natural the shapes and strokes will become and you'll be able to work on some beautiful personal projects in no time!

The table below shows on which pages you can find the complete set of letters (and oftentimes numbers) to follow as you practice, and on which page the pre-ruled practice sheet for each alphabet is located. (Remember: "majuscule" refers to uppercase letters and "minuscule" refers to lowercase letters.)

Where to Find It

NAME OF CALLIGRAPHY HAND	COMPLETE ALPHABET	PRE-RULED PRACTICE SHEET
Foundational	page 24	page 109
Foundational Majuscule	page 25	page 109
Carolingian Minuscule	page 26	page 110
Italic	page 27	page 111
Italic Majuscule	page 28	page 111
Italic Swash Majuscule	page 29	page 112
Roman	page 30	page 113
Uncial	page 31	page 114
Modern Half-Uncial	page 32	page 115
Gothic	page 33	page 116
Gothic Majuscule	page 34	page 117
Gothicized Italic	page 35	page 118
Gothicized Italic Majuscule	page 37	page 119
Batarde	page 38	page 120
Batarde Swash Majuscule	page 39	page 121
Versals	page 40	page 122
Lombardic Versals	page 41	page 123

Learn more about calligraphy at http://CariBuziak.artistsnetwork.com

Foundational & Foundational Majuscule

nib width: 5
ascender/descender nib width: 7
pen angle: 30°

Carolingian Minuscule

nib width: 3
ascender/descender nib width: 8
pen angle: 30°

Learn more about calligraphy at http://CariBuziak.artistsnetwork.com

Italic & Italic Majuscule

nib width: 5
ascender/descender nib width: 8
pen angle: 45°

There's a 5-degree slant on all stems in Italic.

Italic Swash Majuscule

nib width: 8
pen angle: 45°

There's a 5-degree slant on all stems in Italic.

Learn more about calligraphy at http://CariBuziak.artistsnetwork.com

Roman

nib width: 7
pen angle: 30°

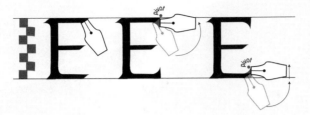

1 Keeping the top nib corner planted on the paper, pivot the nib on that corner to pull the serif out.

2 As the nib is pivoted for a bottom serif, the nib can slide slightly upwards to keep the bottom line level with the horizontal line.

Uncial

nib width: 4
ascender/descender nib width: 5
pen angle: 5°

5°

Learn more about calligraphy at http://CariBuziak.artistsnetwork.com

Modern Half-Uncial

nib width: 4
ascender/descender nib width: 6
pen angle: 20°

20°

Gothic

nib width: 5
ascender/descender nib width: 7
pen angle: 45°

*Letter spacing is equal to
approximately 1 stroke width.*

Learn more about calligraphy at http://CariBuziak.artistsnetwork.com

Gothic Majuscule

nib width: 6
pen angle: 45°

1 Draw the main body of the stroke, then return to the starting corner. Using the corner of your nib, pull some of the wet ink into a small curl.

2 Use the corner of the nib to draw a small curl at the end of the stroke.

Gothicized Italic

nib width: 5
ascender/descender nib width: 7
pen angle: 45°

Gothicized Italic Majuscule

nib width: 6
pen angle: 45°
diagonal stroke
angle: 30°

1 Keeping the top nib corner planted on the paper, pivot the nib on that corner to pull the serif out.

2 Hold the pen nib at different angles to complete the hairline strokes. Add these details last.

3 Draw the main body of the stroke, then return to the starting corner. Using the corner of your nib, pull some of the wet ink into a small curl. To draw an end curl, use the corner of the nib, draw a small curl at the end of the stroke.

Batarde

nib width: 4
ascender/descender nib width: 6
pen angle: 35°

35°

The "f" and "p" in this letterform require a bit of pen manipulation to get the downward stroke. Begin with your pen nib at a 35-degree angle and pull downward. As you slide the nib down, twist the pen slowly so the line tapers neatly.

Learn more about calligraphy at http://CariBuziak.artistsnetwork.com

Batarde Swash Majuscule

nib width: 10
pen angle: 35°
diamond pen angle: 45°

35°

Versals

nib width: 5
ascender/descender nib width: 6
pen angle: none

Learn more about calligraphy at http://CariBuziak.artistsnetwork.com

Lombardic Versals

nib width: 5
ascender/descender nib width: 6
pen angle: none

Note: The decorated hairlines can end in any number of designs. Here are some ideas but feel free to make up your own!

Index

A DAVID & CHARLES BOOK
Copyright © David & Charles Limited 2011

David & Charles is an F+W Media Inc. company
4700 East Galbraith Road
Cincinnati, OH 45236

First published in the UK in 2011
First published in the US in 2011

Text copyright © Cari Buziak
Photographs copyright © Cari Buziak

UK edition Commissioning Editor: Freya Dangerfield;
Editor: Felicity Barr; Designer: Sarah Clark

US edition Editors: Jennifer Lepore and Kathy Kipp;
Designers: Jennifer Hoffman and Marissa Bowers;
Production Coordinator: Mark Griffin

A catalogue record for this book is available from
the British Library.

ISBN-13: 978-1-4463-0056-5 paperback
ISBN-10: 1-4463-0056-0 paperback

Printed in China for David & Charles
Brunel House, Newton Abbot, Devon

David & Charles publish high quality books on a wide
range of subjects.
For more great book ideas visit: www.rubooks.co.uk

METRIC CONVERSION CHART

TO CONVERT	TO	MULTIPLY BY
Inches	Centimeters	2.54
Centimeters	Inches	0.4
Feet	Centimeters	30.5
Centimeters	Feet	0.03
Yards	Meters	0.9
Meters	Yards	1.1

About the Author

Cari Buziak is an instructor for the International Conference for Lettering Artists, and also teaches distance-learning workshops with her Aon Celtic Apprenticeship Program. She's created logos, jewelry, rubber stamps, machine embroidery, cross stitch, clothing, costumes, the largest Celtic stencil line on the internet, laser engraving and etching, 3D milling, print and web. Cari has 45+ lines of internationally produced and distributed licensed products and she's recently created book covers and illustrations for several publishers. Visir Cari's website at www.aon-celtic.com.

Dedication

To my dad, an adventurer with the biggest heart I know. Love you!

Acknowledgments

A big thanks and a hug to Derek for his support and encouragement, and to my editor Kathy for her calming influence and help in a hectic project!

Ideas. Instruction. Inspiration.

Find the latest issues of *The Artist's Magazine* on newsstands, or visit www.artistsnetwork.com/magazines.

These and other fine North Light and IMPACT Books are available at your local art & craft retailer, bookstore or online supplier.

Dreamscapes Myth & Magic by Stephanie Pui-Mun Law • paperback • 176 pages

DragonArt Digital Dragons with J "NeonDragon" Peffer • DVD running time: 64 minutes NTSC

Visit www.artistsnetwork.com and get Jen's North Light Picks!

Get free step-by-step demonstrations along with reviews of the latest books, videos and downloads from Jennifer Lepore, Senior Editor and Online Education Manager at North Light Books.